IMAGES
of America

WHITE CLOUD

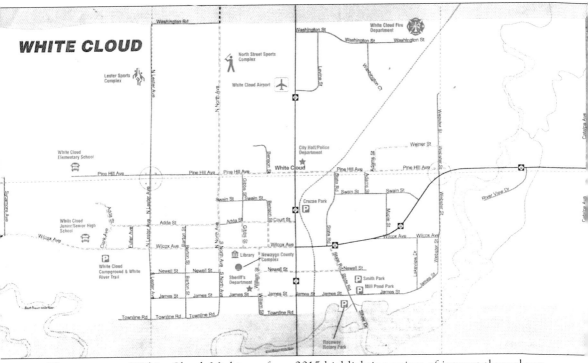

This is a map of White Cloud, Michigan, from 2015 highlighting points of interest throughout the city. (White Cloud Community Library.)

IMAGES
of America

WHITE CLOUD

White Cloud Community Library

ARCADIA
PUBLISHING

Published by Arcadia Publishing
Charleston, South Carolina

Printed in the United States of America

Library of Congress Control Number: 2023931260

For all general information, please contact Arcadia Publishing:
Telephone 843-853-2070
Fax 843-853-0044
E-mail sales@arcadiapublishing.com
For customer service and orders:
Toll-Free 1-888-313-2665

Visit us on the Internet at www.arcadiapublishing.com

*This book is dedicated to the ones who came before
us and paved the way from "rails to trails."*

CONTENTS

Acknowledgments

The White Cloud Community Library book committee is made up of Jan Smith, Mary Bleiler, Cindy Sharp, Marce Hansen, Laurie Deater, Doris Sirk, Bob Burke, Patricia Ebenstein, Cindy Stowell, Kathie Lewis, and Pamela Miller. Other contributors are Rosie Alger and Suzanne Fetterley along with the White Cloud Community Library history section, which houses the collections of Martha Evans and Dr. Sidney Douglass.

This White Cloud sesquicentennial book was made financially possible by the following individuals and families. Each donor gave $150 to commemorate White Cloud's 150th birthday in July 2023: Jan E. Smith in honor of Everett and Anna Brooks; Charles P. Smith in honor of Leonard and Dorothea Smith; Pamela Miller in honor of Mike and Marjorie Fetterley; Steve and Marce Hansen and family; John and Ruth Graves family; Suzanne Fetterley in honor of Bill and Georgia Martin and Clayton Fetterley; Shelley Cook in honor of Terry and Nancy Arnold; Clint and Shelley Cook in honor of their daughter Taylor Jean; White Cloud VFW Post 2053 in honor of all veterans; Steve and Mary Bleiler in honor of Everett and Joan Bleiler and Byron R. and Margaret Fowler; Peter W. and Mary F. Graves; Walter and Emma Graves family; Orrie and Pat Ebenstein and family; Bob and Vicki Burke and family in honor of Andy, Laura, and Richard Burke; Jim and Diane Brandt in honor of Bill and Irene Brandt and Kenneth Brandt; Al Fry family in honor of the descendants of Homer and Alice (Terwillegar) Fry; Leonard Sr. and Nancy Harper and family; Grant and Lynn Fry in honor of Otis and Bernona Fry, the first White Cloud librarian; Rick and Cindy Sharp and family; Carl Mast and Lisa Margaret Martin in honor of Terry Mast; Terry and Sandy Mast in honor of Carl and Lois Mast; Riley and Ingle Allers family; Genie Bopp in honor of Calvin and Gretchen Bopp; Joan, Leon, June, and Dean in honor of Elmer and Doris May; Curt A. and Sandra J. Crandell family; Jennifer Fry in honor of Otis and Bernona Fry; Duane and Luann Cruzan and family in honor of Marion and Ruth Cruzan and Thomas and Pauline Maike; Norma Rudert in honor of Don and Eric Rudert; Charles and Alice Dudgeon family; Kevin and Therese Crisman and family; Bill and Judy VanAndel family; Gordon and Rose Alger and family; Ellis and Dorothy Fry family; Marie Cordts Sovinski; Ashley Plotts and baby David; Martha Mudget Evans; and Dr. Sidney Douglass.

Unless otherwise noted, all photographs in this book are owned by the White Cloud Community Library history section.

INTRODUCTION

In 1868, Lester C. Morgan built the first sawmill in Morgan Station, also known as Morganville or the Village of Morgan. Lester Morgan and Sextus Wilcox founded a lumber camp in Everett Township in 1871. Morgan was a noisy little village, with lumberjacks spending their wages in the many saloons.

A dam was constructed on the White River in 1872. On July 22, 1873, Lester Morgan established a depot and post office nearby and officially called it Morgan Station. The branch of the Chicago & West Michigan Railroad that ran to Morgan Station from Muskegon was completed to Big Rapids in 1873.

At the completion of the wooden railroad trestle over the White River south of town, the Grand Rapids, Newaygo & Lake Shore Railroad reached Morgan Station on September 29, 1875. The trestle is still in use after 148 years of service.

In 1875, the Village of Morgan had two railroad lines. The Grand Rapids, Newaygo & Lake Shore Railroad ended in the village for a short time, which necessitated the construction of a turntable, located near the grist mill. White Cloud also had a water tower, engine house, and coaling station. The Grand Rapids, Newaygo & Lake Shore Railroad was later extended to Traverse City. The second depot was constructed about this same time to accommodate both railroads. An 1880 atlas shows the depot located at the junction of these two lines. It appears there was not much room here, necessitating a third and final depot to be built.

In 1879, Sextus Wilcox had the village's name changed to White Cloud when his partnership with Lester Morgan dissolved and Morgan moved his operations north. Neither of these lumber barons lived in White Cloud.

The Pere Marquette Railroad purchased both railroad lines running through White Cloud in 1899. The third and final depot was built and offered 24-hour service to accommodate 12 daily passenger trains as well as two night flyers. The depot sat between the Atlantic and Pacific Hotels and was the hub of the town.

As White Cloud celebrates its sesquicentennial from its official beginning in July 1873 to July 2023, we hope you enjoy this historical walk down memory lane.

One

EARLY DAYS

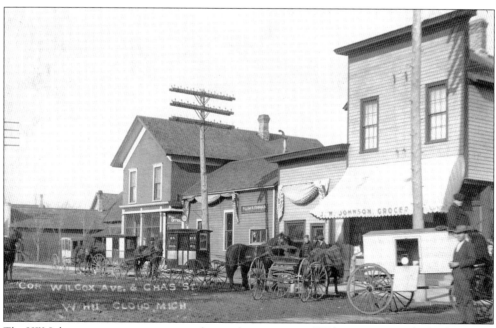

The J.W. Johnson grocery store was on the northwest corner of Wilcox Avenue and Charles Street. The next building was part of the grocery store, followed by the *White Cloud Eagle* newspaper office, then the White Cloud post office. A close look reveals the marking "U.S. Mail and Rural Free Delivery #2" on the horse-drawn buggy at center.

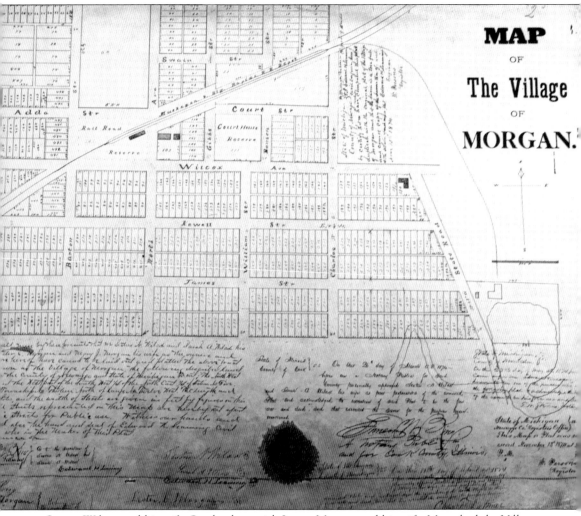

Sextus Wilcox and his wife, Sarah, along with Lester Morgan and his wife, Mary, had the Village of Morgan platted in March 1874. This plat map is still used today, with the descriptions on it used for property lines and tax records. For example, Lot 277 of the Village of Morgan now has the address of 1281 East James Street in White Cloud.

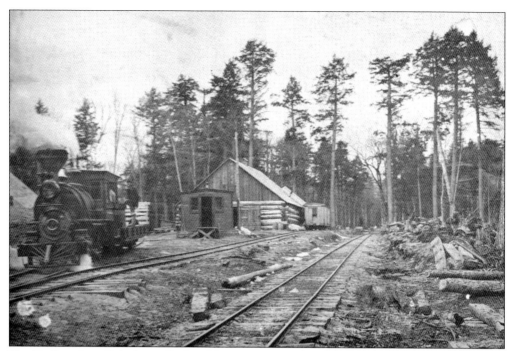

The Big Rapids and Muskegon Railroad Reserve consisted of the entire block from Wilcox Avenue to Adda Street and North Street to Barton Street. Lester Morgan cleared the area and established a post office in a railroad car near the tracks on June 22, 1873. The first depot was made of logs and is one of the four buildings that appears on the Village of Morgan map on the previous page.

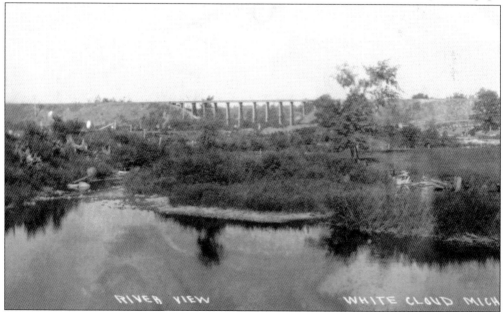

The Great Railroad Trestle is the bridge that sits over the White River just south of White Cloud. It was completed on September 29, 1875. The bridge is 178 feet between two abutments on each end. It is around 37 feet above the water and remains one of the few wooden bridges in Michigan still in use today.

WOLF CERTIFICATE.

Newaygo

State of Michigan, County of......*Newaygo*......ss.

BE IT REMEMBERED, that on this...*1st*...day of...*March*...........A. D. 186_6_*Howard Robinson*.........an inhabitant of the said State of Michigan, personally apppeared before the undersigned, a Justice of the Peace, in and for the township of *Big Prairie* in said county and State, and being by me duly sworn, says that on.....*Monday*.........the *26th*...day of...*February*.....186_6_ within the limits of the said township of......... ...*Big Prairie*......he killed by...*shooting*..............the wolf....................the head of which (with the skin and ears entire thereon) is now here produced; that the mother of said wolf...............was not taken before she had brought forth, nor was such mother or her den discovered by or known to deponent and she spared until she should bring forth; nor was the wolf.............so killed, taken and spared, or spared alive not yet taken, by deponent in order to obtain a larger bounty for killing the same.

Howard Robinson

Before me

Alexander Dalzell...Justice of the Peace.

State of Michigan, County of......*Newaygo*......ss.

We do hereby certify that on the...*1st*...day of......*March*..........A. D. 186_6_*Howard Robinson*......who is an inhabitant of this State, appeared before us with the head of a wolf..............(with the skin and ears entire thereon) for the killing of which he claims bounty, and having made diligent inquiry in the premises we are satisfied, and so certify that the said wolf......was over three months old, and was killed by the said...*Howard Robinson*..... at the time and place and in the manner stated in the foregoing affidavit, and that he is entitled to the bounty allowed by law therefor. We further certify that we have burned to ashes the head of such wolfwith the skin and ears entire thereon.

Dated at *Big Prairie*......this...*1st*.......day of...*March*.........A. D. 186_6_

Alexander Dalzell...Justice of the Peace.

Henry Utley.......Highway Commissioner,

...............................Justice of the Peace.

State of Michigan, County of......*Newaygo*.........ss

I,..*Melvin W. Scott*.....Clerk of the Board of Supervisors of said county, do certify that the above is a true copy of a wolf certificate allowed by said Board, at their session for 186_6_

WITNESS my hand and seal of said county, this *26th*..day of...*April*...........A. D. 186_7_

Melvin W. Scott.......Clerk.

L. S.

5 Rev 5
M. W. S.
April
20th
1867.
5 March 6

Wolves were killing livestock and threatening residents in the early days of Newaygo County. The county supervisors paid bounties on slain wolves. The hunter was required to submit a wolf certificate signed by the justice of the peace, along with the wolf's head, to receive payment.

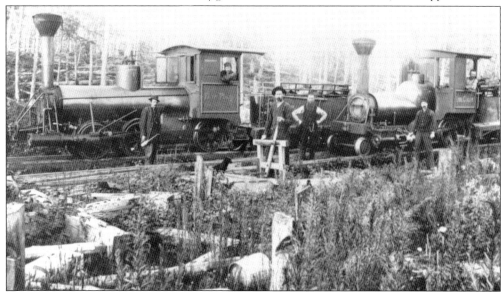

County Clerks Office
Newaygo County Mich

This certifies that, at a meeting of the Board of Supervisors of the above named County held this day at the County Clerks Office in the above named County there was allowed Abel Bills a Bounty of Eight Dollars for killing a full grown wolf in the Township of Croton in said County.

Signed by Order of the Board
And Dated January 26th A.D. 1856
J.W. Standish, Clerk

James Barton (Chairman of the Board of Supervisor)

The board of county supervisors met four times a year, and at each meeting, six to eight wolf pelts were usually brought in. The supervisors paid a bounty of $8 for each full-grown pelt; hunters received less for a wolf that was not fully grown. The wolves had to be shot, not trapped.

The first three locomotives built for logging use were sold to James Alley of the Alley Lumber Company. In June 1879, engine No. 1 was listed as a Shay Fontaine type, along with engine No. 2, the "Lima Giant," and engine No. 3, the "Fair Play." All three were made for logging operations on narrow-gauge wood rails.

13

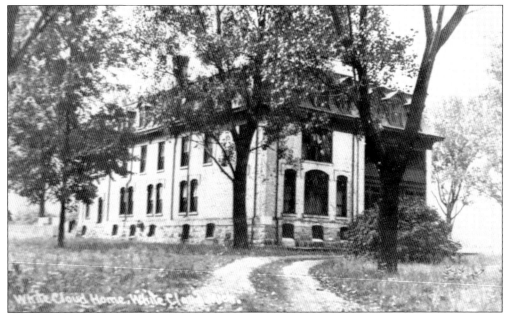

The majestic Morgan Inn was built for Lester and Mary Morgan in 1868. The Morgans never lived in White Cloud. The inn was on the west side of North Street north of Adda Street. At this time, North Street was the village's main street and connected to Townline Road, which led to Alleyton.

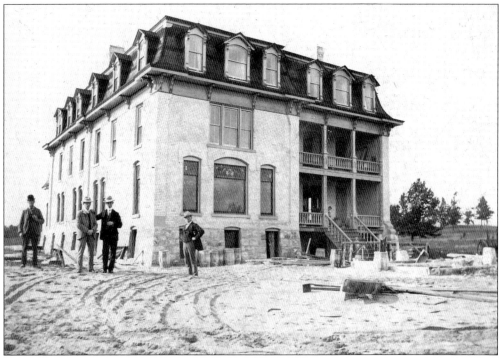

In 1889, Dr. John Branch moved to White Cloud. In 1900, Dr. Branch—along with his brothers Adelbert, Mortimer, Erastus, and Charles Field—financed the purchase of the Morgan Inn. They had the inn moved north on North Street, and it became the White Cloud Hospital and Sanitarium. In 1915, Dr. Branch ceased operating the hospital. This is now the Maple Lane Mobile Home Park.

14

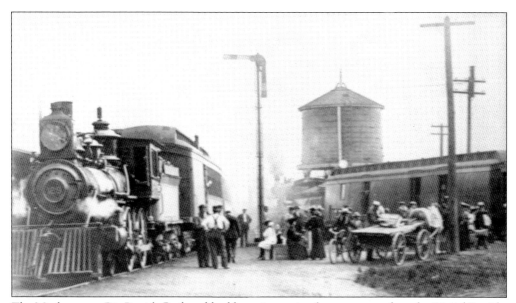

The Muskegon to Big Rapids Railroad had been in service for two years when the Grand Rapids, Newaygo & Lake Shore Railroad arrived in 1875, increasing the water and fuel needs at the junction. At the end of the 19th century, there were a dozen daily passenger trains and hundreds of monthly freight trains traveling through town. The water tank in White Cloud was constructed around 1873.

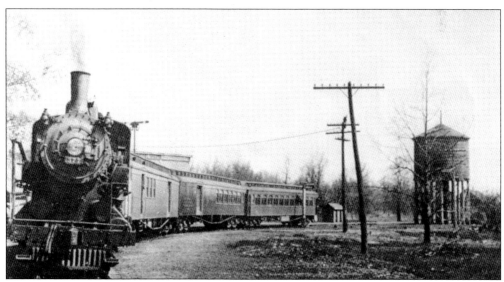

During the early days, trains needed water at nearly every stop because they did not have much storage. When tenders were used, a train could travel from 100 to 150 miles before needing to refill. Some of these early engines used a pound of coal and one gallon of water per second.

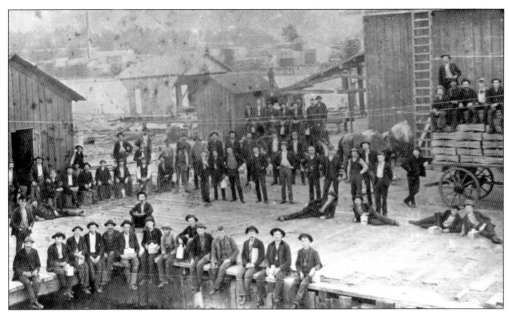

The Wilcox and Morgan Shingle and Lath Mill was built in 1874. It was owned and operated by Sextus Wilcox and Lester Morgan. The mill was where White Cloud's powerhouse later stood on the raceway, on the south side of James Street between State Street and the railroad tracks. It is now a paved parking lot for Rotary Park. (Briggs Lumber Company.)

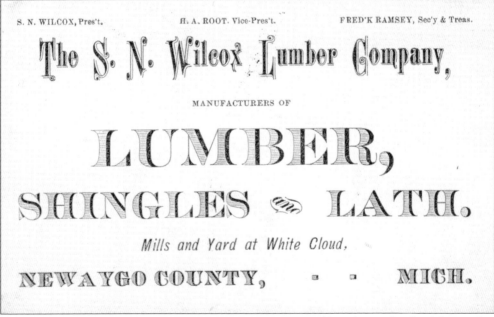

In 1873, Sextus Wilcox and Lester Morgan built a large steam mill on the north side of the pond. A year later, they built a water-powered shingle and lath mill. In December 1879, Wilcox and Morgan reorganized under the name S.N. Wilcox Lumber Company, and advertised as manufacturers of lumber, shingles, and lath.

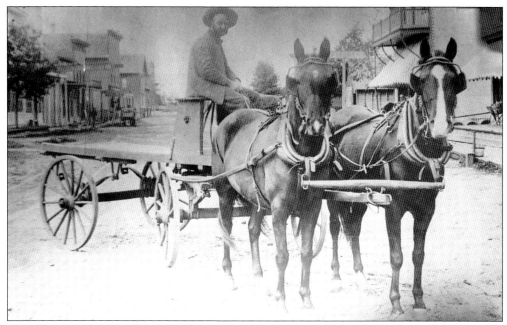

This photograph was taken on Wilcox Avenue in the late 1880s. The horses and the dray are presumed to be the Morgan Lumber Company's equipment. A dray is a cart without sides; these were often used for moving heavy items to the lumber camps.

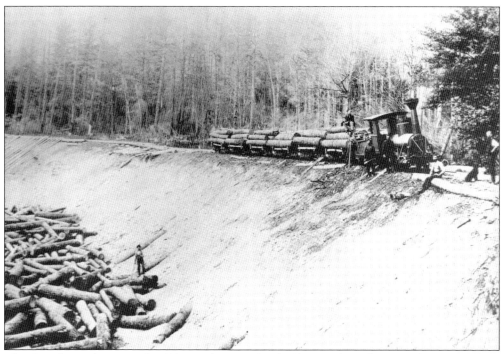

The Fair Play is shown in the 1880s with a trainload of logs at the rollway on the south side of the Mill Pond in White Cloud. Rail lines ran to the west and south, with numerous spurs leading into the woods in all directions.

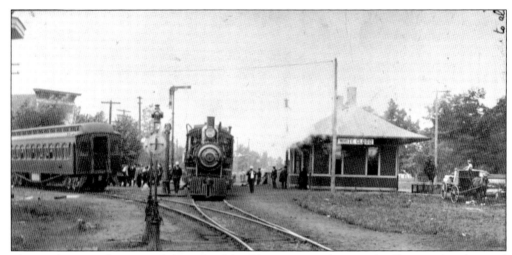

The Muskegon and Big Rapids branch of the Chicago & Michigan Lake Shore Railroad passed through White Cloud in 1873. The northbound Grand Rapids, Newaygo & Lake Shore Railroad followed in 1875, ending in White Cloud, which necessitated the construction of a turntable near the old co-op mill. Both lines were sold to the Pere Marquette Railroad in 1899.

Late in the 19th century, a quarter-mile horse-racing track was built east of the depot in the vicinity of the Little League fields. Jim Terwillegar and his prize steed often participated in the races. The day before a big race, the horse fell and broke a leg, necessitating the destruction of the beautiful animal.

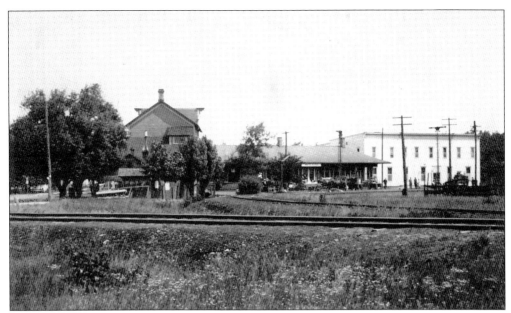

The Atlantic Hotel was built in 1881 just north of the Pere Marquette depot. D.A. McIntyre operated the depot. In 1889, the hotel was sold to C.G. Ubellar. The main floor had an auditorium, stage, and dining room. There were rooms for rent on the second floor. The hotel had electric lights, heated air, and lavatories on each floor.

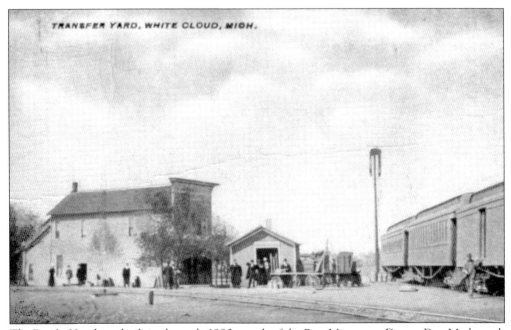

The Pacific Hotel was built in the early 1880s south of the Pere Marquette Depot. Dan Matheson's Last Chance Saloon occupied the main floor and had rooms to rent on the second floor. Matheson ran the saloon and hotel for a quarter of a century. It provided a comforting spot for tired and thirsty travelers.

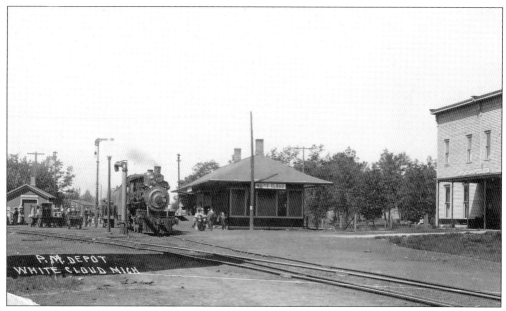

The third depot was built east of Charles Street around 1900 by the Pere Marquette Railroad on the north side of the railroad tracks. Passenger service went from Traverse City to Chicago. The depot provided 24-hour service to accommodate two night passenger trains. All passenger service through White Cloud ended in 1963.

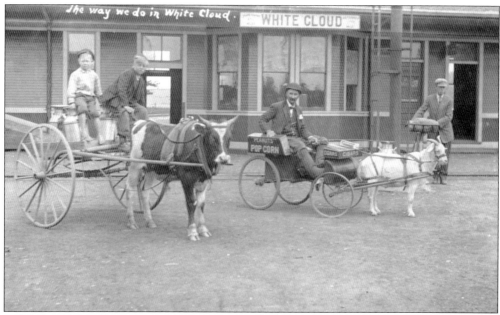

Billy McGogan and his goat met the trains at the White Cloud depot. McGogan became disabled after being shot while stealing a chicken to feed his family. He then sold popcorn, peanuts, candy, cigars, and chewing gum to railroad passengers to provide for his family.

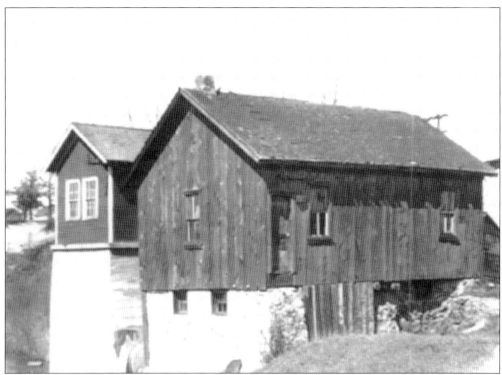

Sextus Wilcox and Lester Morgan erected a water-powered planing and shingle mill on the Mill Pond's raceway. It was sold to the Village of White Cloud in the early 1890s. The village converted the building into a power-producing plant. Note the water wheel between the two buildings. The power was turned off around midnight in the summer to conserve water in the pond.

This image shows the White Cloud Raceway. Fuel costs were eating up the profits, and the power production business was sold to Consumers Energy in 1951. On August 11, 1952, Consumers Energy shut off the diesel engines, and the city's power was converted to Consumers Energy. This site is now a parking lot for Rotary Park.

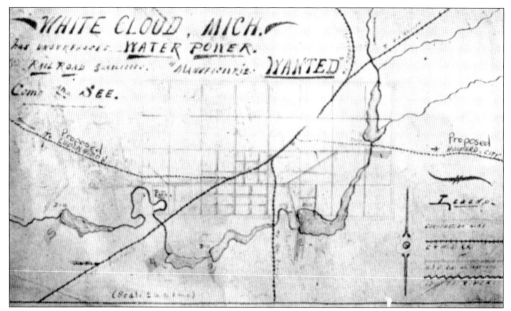

To get logs from upriver to the mills, dams were built every few miles. The dams were five to six feet high and made of wooden gates. The gates were closed to raise the water and opened to wash logs downstream to the next basin. This map shows five of these dams from White Cloud to Alleyton.

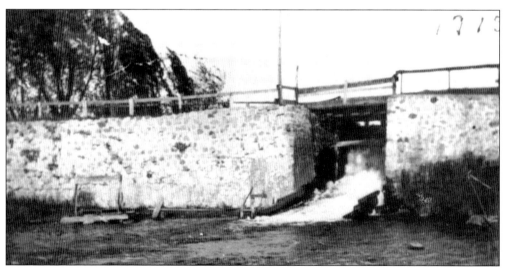

The White Cloud dam was built in 1872 and rebuilt in 1920. The 1920 dam stood until the flood in September 1986, when the dam broke and flooded the lower White River area. The dam was rebuilt in 1990 and still stands today.

The old icehouse was on the Mill Pond at the swimming beach. The ice was cut by hand into squares and stored in sawdust. The icehouse was part of the business owned by William Flaherty in 1939. Pictured here are Arnie Stark and Marie Cordts Sovinski (right). As of 2023, Sovinski is still alive and well at 102. (Bob Burke.)

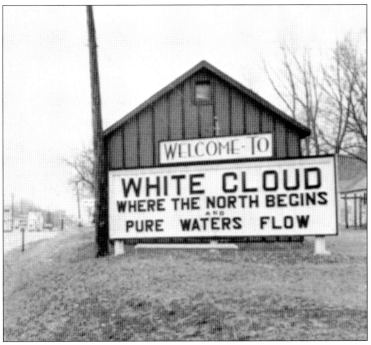

The sign that greets visitors as they enter White Cloud on the M-37 highway includes the phrase that was established as the city's motto in the 1920s—"Where the North Begins and Pure Waters Flow." The idea came from a poem brought back from Canada by Bill Martin.

23

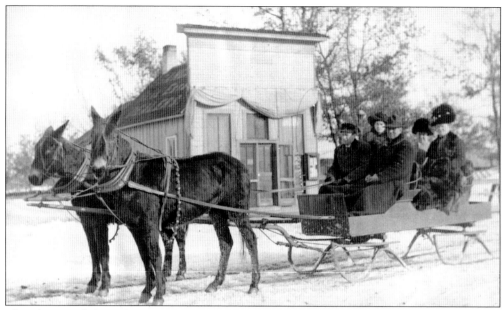

This photograph from the winter of 1915 shows Dave Moote (left) driving a span of mules pulling a sleigh. In the front seat with Moote is Jim Patterson. From left to right in the rear are Neva, Lydia, and Emma Patterson. The building in the back is the Branch Brothers real estate office.

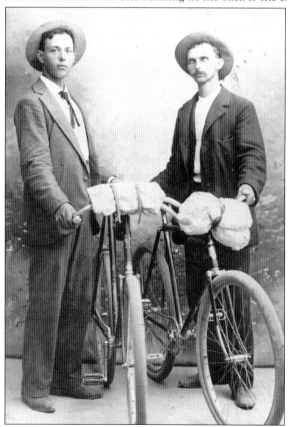

Around 1895, Harry Douglass (left) and Art Crofoot took a weekend trip on their bicycles to Grand Rapids. According to Dr. Sidney Douglass, Crofoot told him they took their "steeds" right into a studio for this photograph. The bikes, known as "wheels," were manufactured at the White Cloud Bicycle Factory.

The White Cloud Shoe Factory (pictured) was on the southwest corner of Wilcox Avenue and Barton Street. Earlier occupants of this building included a bicycle factory, a skating rink and billiards parlor, and Dr. Vernon's Feed Barn. It was sold to Sergeant Bowman VFW Post 2053 and was used for VFW events until it was sold and intentionally destroyed by fire in 1989.

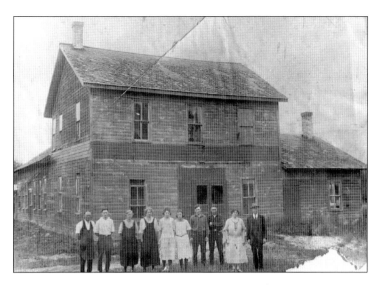

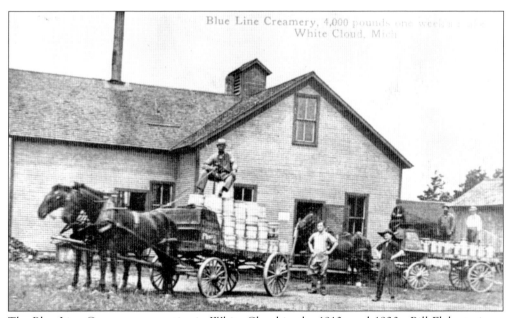

The Blue Line Creamery was active in White Cloud in the 1910s and 1920s. Bill Flaherty is on the load of butter in the wagon at left; Fay Wilson is seated at the front of the wagon filled with cans. Two others on the rear of Wilson's load are unidentified. A Mr. Martin, standing near the center of the image (in the apron), is on the ground along with Ford Fry. The creamery was on the south end of Williams Street.

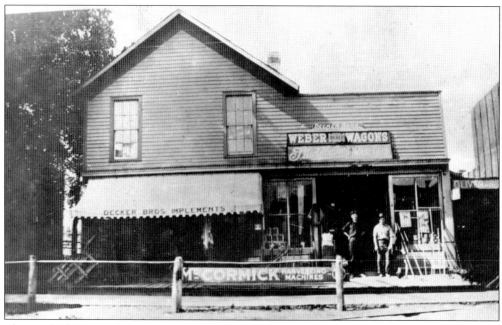

This is Charles Decker's implement store on the north side of Wilcox Avenue between Gibbs Street and the alley to the west. It was operated for many years by M.D. Hayward. This photograph was taken in the 1920s.

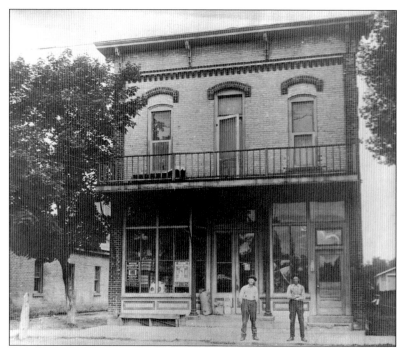

This building was built around 1880 and was operated as a hotel until 1882. It was later a saloon and dance hall for many years. George Patterson purchased the building and ran a feed store with living quarters upstairs. Patterson is pictured here on the right with John Gustin.

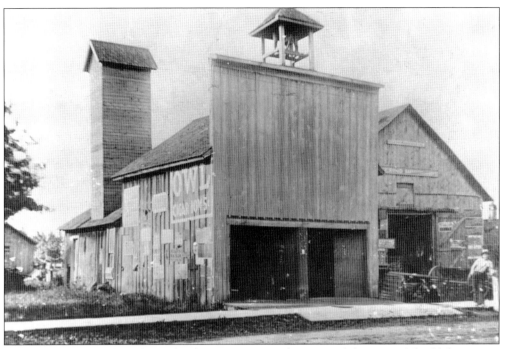

This photograph of the White Cloud Fire Barn was taken around the start of the 20th century. Note the fire bell and the tower for drying hoses. The village offices were in the rear of the building. This building was removed around the time the new city hall was built in 1908; this location later became the Newaygo County Courthouse.

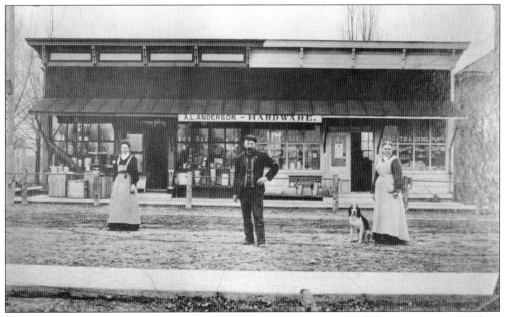

Around 1910, the Alex Anderson store was located on the corner of North Street and Wilcox Avenue, where Dr. Sidney Douglass's office was later built. Years later, the building was added on to, giving the store a two-part appearance. Pictured from left to right are Maude Scudder, Alex Anderson, and his wife, Sarah.

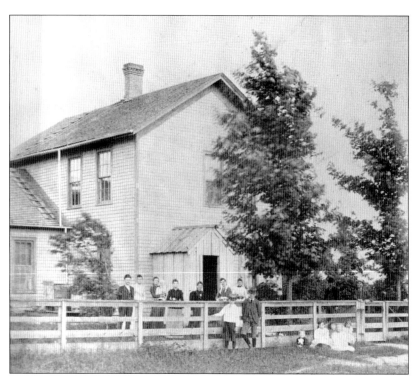

The first house built in Morgan is on the northeast corner of North and Pine Hill Streets and was built by J.M. Gibbs in 1872 for Sextus Wilcox. Wilcox drowned in Lake Superior in 1881 on a fishing trip, and the house was taken over by William Gibbs. Known as the Gibbs house, it is still occupied 150 years later.

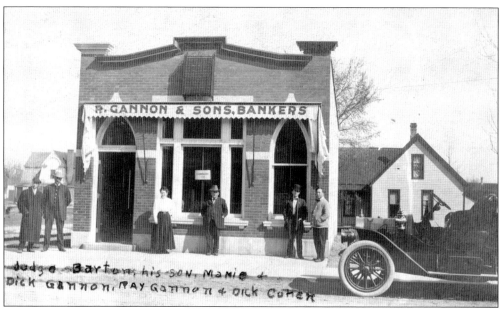

In the early 1900s, Richard Gannon and his two sons, Charles and Ray, took over the private bank that was originally organized by Mitt and Cornelius Lenington. It then became known as the Gannon and Sons Bank, which was on the northeast corner of Wilcox Avenue and Benson Street. Pictured from left to right are Judge Barton and his son, Mamie and Dick Gannon, Ray Gannon, and Dick Coker.

Two

SCHOOL DAYS

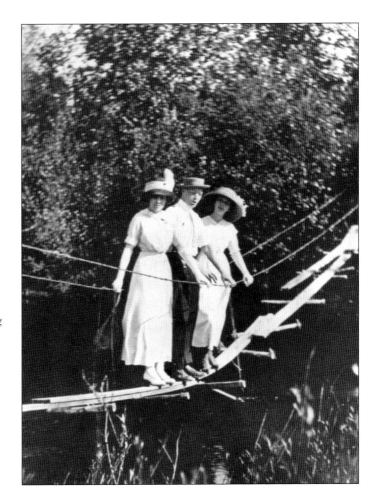

For many years, there was a cable-supported swinging bridge over the White River about a half mile below the M-37 bridge. On this 1910 summer day, from left to right, Bessie McCormick, Lloyd Whiteman, and Marie McCormick pose on the bridge. The swinging bridge was a shortcut to school for many children.

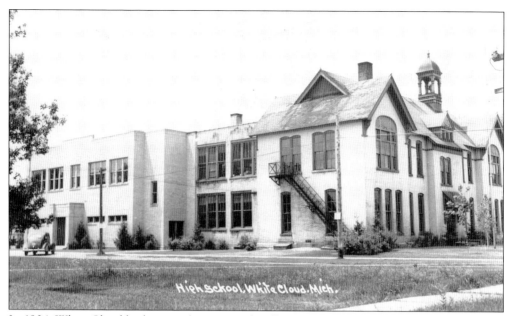

In 1904, White Cloud built a new four-room schoolhouse on the corner of Newell and Williams Streets for first through twelfth grades. In 1936, an addition was built due to higher enrollment. Classrooms and a gymnasium were added to the back of the school. In 1963, this building was sold to Newaygo County. The school was torn down, and a new sheriff's office and jail were built.

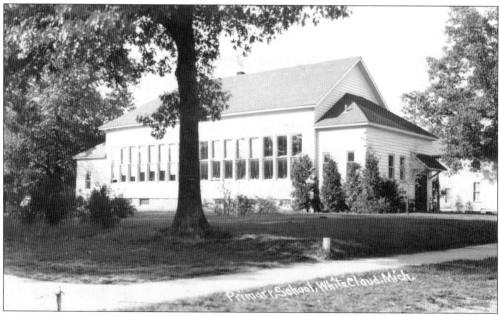

In 1917, White Cloud Public School purchased the Congregational church, which became the White Cloud Primary School, also known as the Annex. This building was on Newell Street just west of the school. In 1947, the country schools were consolidated into White Cloud Schools. In 1954, a new White Cloud Elementary School was completed.

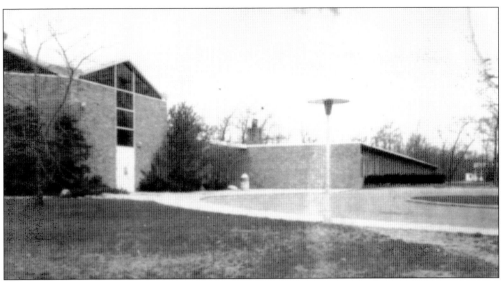

In 1954, White Cloud Elementary School was built on Adda Street. This school was for students in kindergarten through sixth grade. A new school was needed due to the 1947 Michigan state requirement that country schools be consolidated into public schools. This school was renamed the Jack D. Jones Elementary School after his death. Jones was a teacher, coach, and longtime superintendent. (Rosie Alger.)

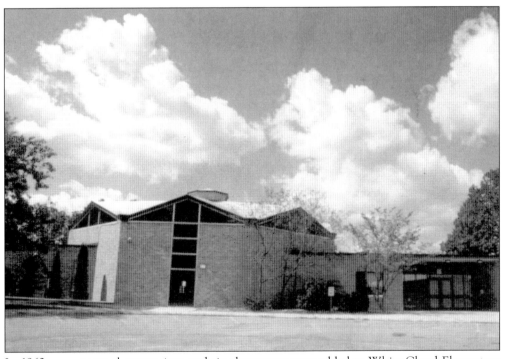

In 1962, an octagonal gymnasium and six classrooms were added to White Cloud Elementary School along with building upgrades. In 1991, a cafeteria, kindergarten rooms, and an art and band room were added along with more upgrades. In 2003, a new elementary school was built. The school was used for a few more years and was demolished in January 2021.

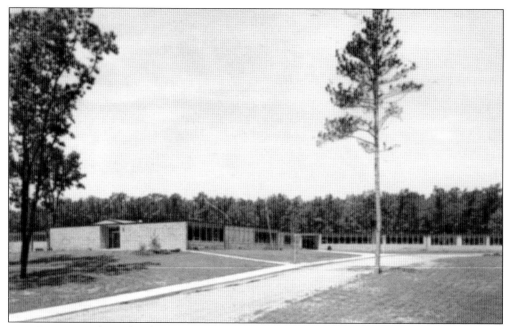

In 1961, a new White Cloud High School and gymnasium was built at 555 East Wilcox Street for students in seventh through twelfth grades. This replaced the aging school at Newell and William Streets. Between 1961 and 1992, as enrollment increased, more classrooms were needed, so portables were added to the north and east sides of the building until a bond millage was passed.

In 1992, the 1961 White Cloud High School building was renovated into what is now White Cloud Junior High for students in fifth through eighth grades. It has its own principal and secretary. A former student remembers carrying desks from the elementary school down the hill to the new junior high.

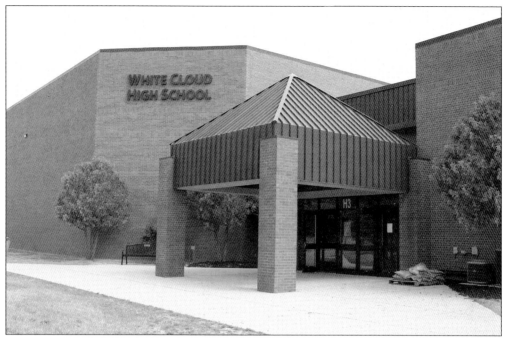

In 1992, a new two-story White Cloud High School and gymnasium was built. The high school and junior high are connected, with the superintendent's office between the two schools. Common areas include the band and choir room, the library, and the cafeteria.

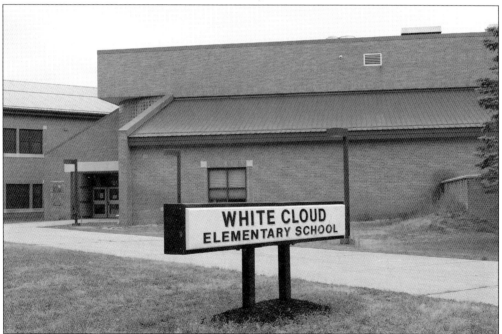

In 2003, a new White Cloud Upper Elementary School was built for students in fourth through sixth grades. Due to the deterioration of Jack D. Jones Elementary School, it was torn down. Kindergarten and first and second grades were consolidated with the upper elementary school, which now holds students in kindergarten through fifth grade.

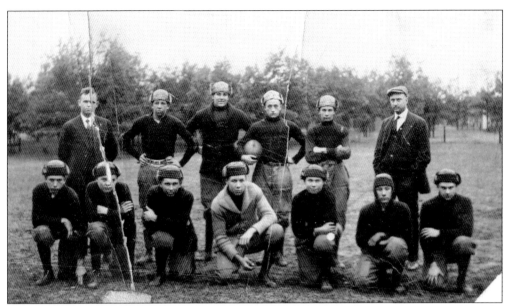

In 1917, White Cloud High School's first football team was coached by C.E. Cooper and later by Ule Malhort. They practiced under a streetlight. Pictured here are, from left to right, (first row) Henry Gustin, Vernon Mickelson, unidentified, Oliver Hepinstall, Harold Clark, Gene Sorden, and Barney Smith; (second row) W.A. Willard, Walter McCormick, Charlie Johnson, Mac Slade, Harold Adams, and Coach Cooper. (Suzie Fetterley.)

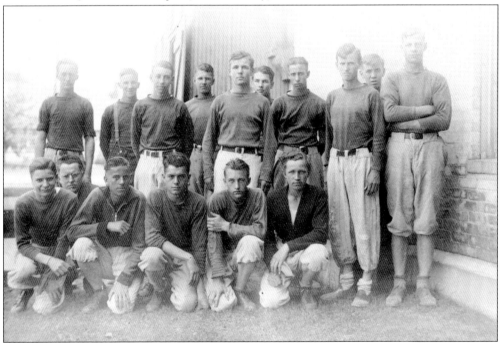

The exact year of this team picture is unknown, but it is probably from the 1934 or 1935 high school baseball season. From left to right are (first row) Carl Gustafson, coach Lloyd Fry, Vern Goyings, Lewis Patterson, Chuck DePung, and Ed Jonaitis; (second row) Walter Sowles, Greg Hart, Don Cruzan, Jim Ferguson, Bill Gannon, Bill Fowler, Ed Lovell, John McIntyre, unidentified, and Ken Goyings.

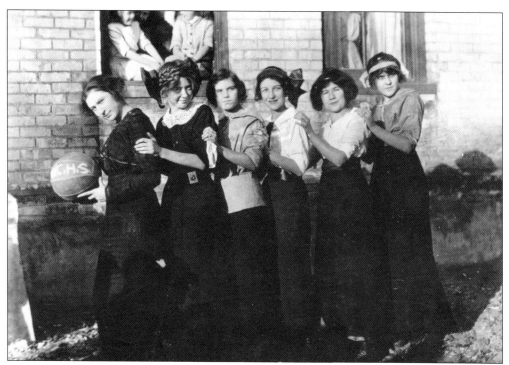

Pictured is the 1914 White Cloud High School girls' basketball team. From left to right are Dora Cohen, Alice Freiberg, Dithea Reed, Blanche Murray, Myrtle Rivait, and Selma Johnson. The girls dressed in their finest to get their photograph taken. Note the young girls peering out the windows, perhaps with excitement of someday playing basketball.

In 1930, with no television or internet and probably very few radios, high school sports were popular not only for the school but also for the town. The 1930 Newaygo County Athletic Association relay champs are pictured here; from left to right are Chet Miller, Barney Fowler, coach Harold Stuck, Bob Miller, and Andy Burke. (Bob Burke.)

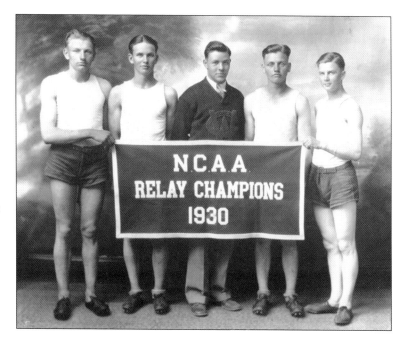

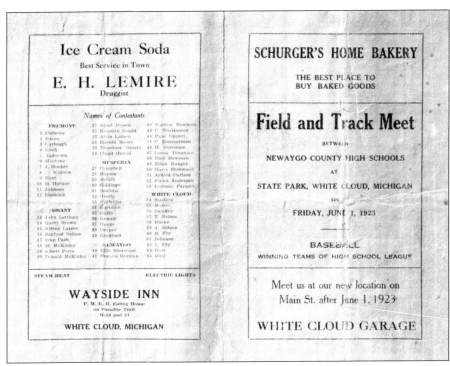

This is a program for the field and track meet held on June 1, 1923. Participating in the event were Fremont, Grant, Hesperia, Newaygo, and White Cloud High Schools. The Newaygo County meet was held at White Cloud State Park. The participants in the events for White Cloud were Sanders, Matson, Barlkey, T. Nelson, E. Burke, J. Nelson, R. Fry, Gust, and Bird. (Bob Burke.)

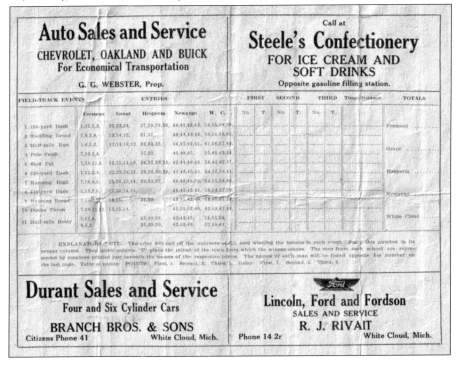

This is the 1930 White Cloud High School boys' basketball team. From left to right are (first row) Forrest Branch, Ancil Sanford, Hollis Mudget, Andy Burke, and Gerald Gustafson; (second row) coach Harold Stuck, Junior Terrell, Marion Cruzan, and Bob Miller. The gymnasium that was part of the old high school on Williams and Newell Streets was not added until 1936. (Bob Burke.)

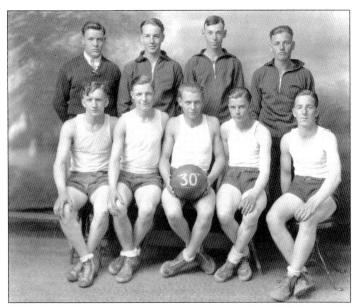

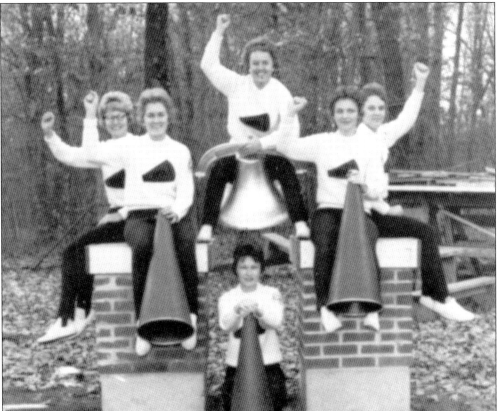

The class of 1963 covered the expenses of installing a victory bell at the White Cloud High School Memorial Athletic Field. This was the original bell from the old high school and rung for each point scored—if the team won the game. Pictured from left to right are Carol Fowler, Peggy Albright, Carol Peck, Marie Pege, and Linda Thompson. Nancy Myers is kneeling in front.

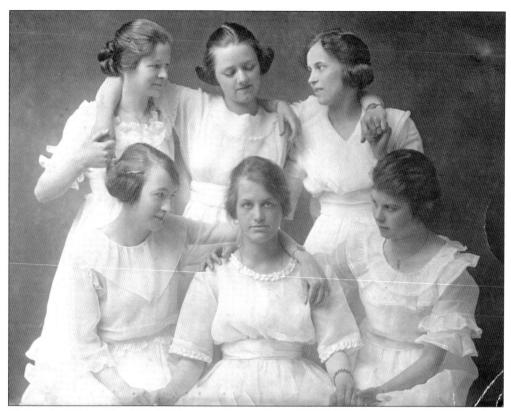

This is the White Cloud High School graduating class of 1920. The six girls are dressed in their Sunday finest. From left to right are (first row) Helen Turner, Olga Lindholm, and Nellie Patterson; (second row) Georgia Patterson, Kathrine Miller, and Adah Johnson. (Suzie Fetterley.)

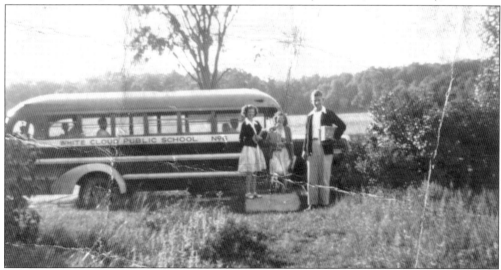

This photograph was taken around 1947 after the consolidation of the country schools. The White Cloud school bus is picking up the Bitson children in front of their home on Laurel Drive in Everett Township. From left to right are Jannette Bitson (Harper), Janice Bitson, and Doug Bitson. Their bus driver was George Decker. (Jannette Harper.)

Three

HOUSES OF WORSHIP

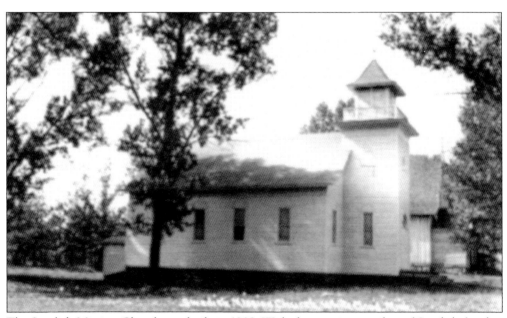

The Swedish Mission Church was built in 1909. With the growing number of Swedish families in the area, it was only natural that they would want their own church. It had visiting ministers who would come by train. In 1935, Elmer Christenson became the church's minister, and served until the church closed in 1966. It was sold and moved to Oak Avenue northwest of Woodville.

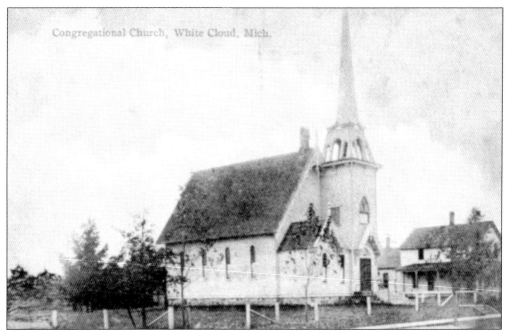

The Congregational church was the first church in White Cloud. It was on the south side of Newell Street between Williams and North Streets. It was built in 1878, with a parsonage to the west. The church dissolved in 1917. White Cloud Public Schools bought the church building a few years later and used it for classrooms and a gymnasium.

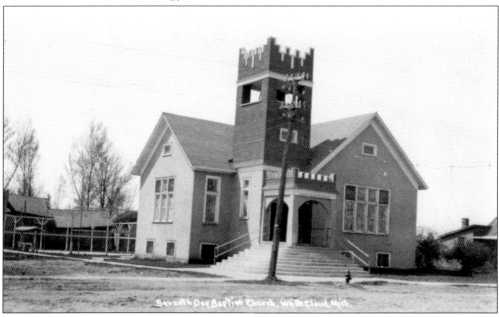

Standing at the corner of Wilcox and North Streets, the Seventh Day Baptist Church traces its roots to members of the Branch family in 1884. After worshiping in rented facilities, the congregation voted in 1888 to begin a building program. Pledges of support included a keg of nails. The new structure had a full basement and even indoor plumbing. The building was dedicated in 1920. (Backward Look.)

Saint Joseph Catholic Church began in 1891. Fr. Nicholas Irmen from Big Rapids came to White Cloud on the daily train. He began his pastoral duties at the home of Maurice and Catherine Stack. With an increased number of worshipers, the original church was constructed on the site where the rectory now stands. The church was moved and expanded in 1925.

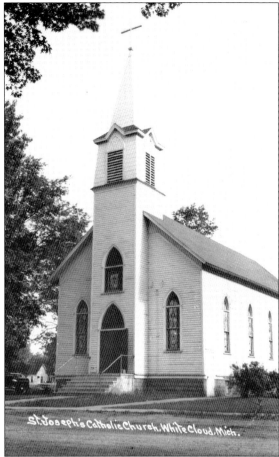

On August 12, 1931, at 8:00 a.m., a small group gathered in a little schoolhouse northeast of White Cloud to organize the Christ Evangelical Lutheran Church of White Cloud. In 1935, a 24 foot by 44 foot church with a vestibule was built on Newell Street at a cost of $2,500. There were 27 charter members involved in starting the church. (Laural Auw.)

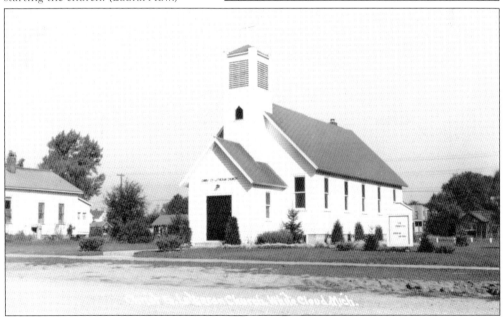

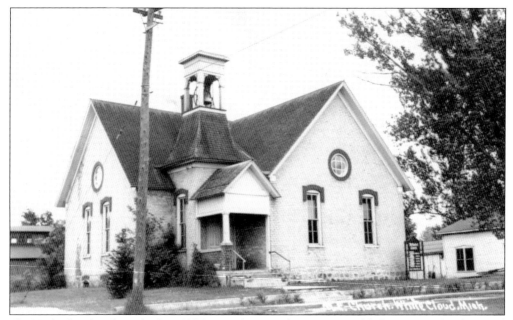

The Methodist church was built in 1885. Two educational rooms were added in 1931. A fire destroyed the church on December 8, 1950. The congregation used the Seventh Day Baptist facility while the church was being rebuilt in the 1950s. A new sanctuary was completed in 2000. The old building is still being used for meetings, Sunday school classes, offices, and fellowship.

In 1939, the Assembly of God organized in the attic of a chicken hatchery on State Street. Eunice McCleary and Belle Terrell were pastors. All members were women except for one man. The first church service was held on Wilcox Avenue on December 26, 1944, and the church's dedication was held on April 10, 1945. Later, the church purchased the movie theater for expansion. (Mary Bleiler.)

Four

A Salute to the Troops

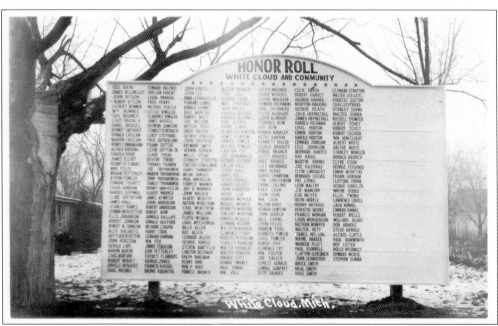

In 1944, an honor roll was erected to list the men and women from White Cloud who served during World War II. The sign was just east of Bird Brothers Food Market. It was frequently updated as the list of soldiers grew. In 2006, a new sign was installed on the corner of Williams Street and Wilcox Avenue.

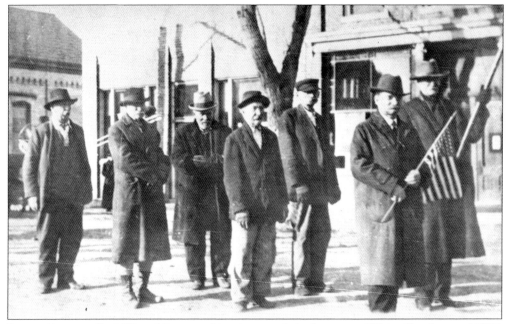

Pictured here are Civil War soldiers marching in a parade in downtown White Cloud around 1915. From left to right are George Martin (grandfather to Suzie Fetterley), Frank Doty, Rufus Hathely, Nathan Lovell, Henry Nichols, Del Branch (not a soldier), and Ben Candee.

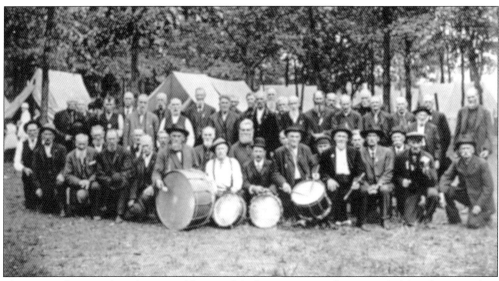

This 1908 photograph is from a Soldiers and Sailors Reunion; these were held each year in late summer at White Cloud State Park. The reunion brought together old acquaintances and families for a weeklong encampment. One of the events included marching and drilling to fife and drum. Another was a daily sham battle with their old muskets.

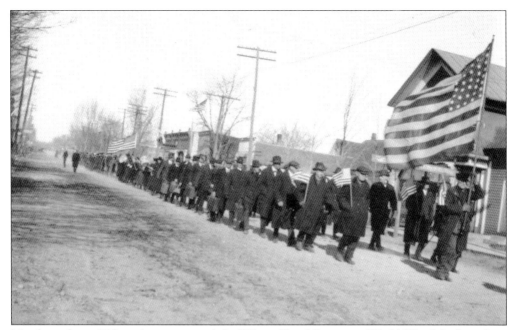

Marching down Wilcox Avenue toward the White Cloud Depot are World War I draftees from Newaygo County, followed by family and friends. There were 64 in this contingent. The *White Cloud Eagle* office is on the right side of the street behind the large US flag.

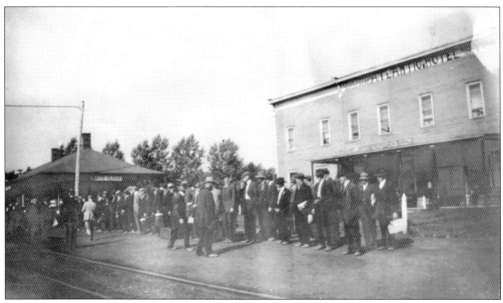

On a solemn day in White Cloud, the first Newaygo County draftees made their way to the White Cloud depot to await the train for duty in World War I. There were 64 young men in this group. The Atlantic Hotel is in the background.

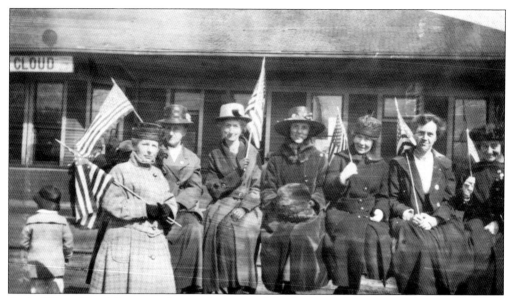

At the White Cloud depot, mothers and wives send the draftees off to war. The depot was the hub of town. Every time the train would take boys off to war, there would be a parade to escort them down the street and right up to the train cars.

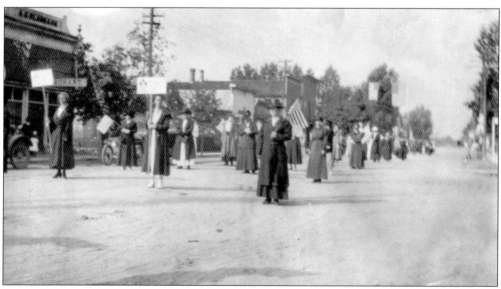

Mothers and wives march in a parade down Wilcox Avenue to the depot in White Cloud to welcome home the men and celebrate the end of World War I. The war ended on November 11, 1918. Pres. Woodrow Wilson proclaimed the first Armistice Day the following year.

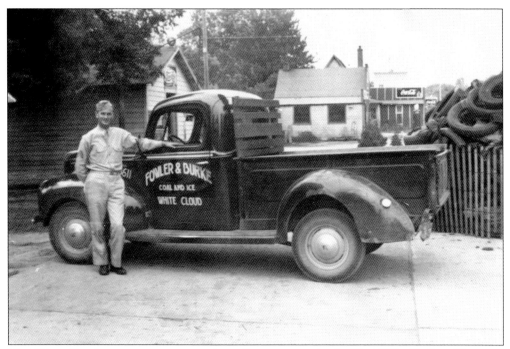

The White Cloud community was united in collecting items for the World War II effort. The items included iron and tires, which were used for weapons and vehicles. Milkweed pods were collected and used to fill life jackets and for parachutes. Byron Fowler is pictured in front of the tire pile near the Standard Gas Station. (Mary Bleiler.)

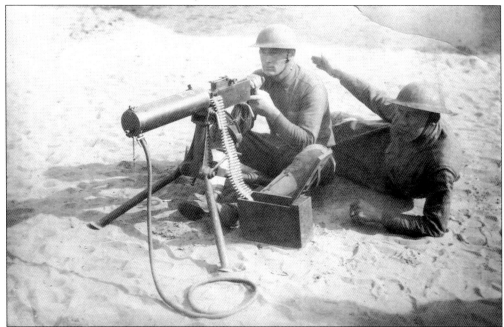

This postcard featuring two World War II soldiers was found in a family attic in White Cloud. Patriotism ran high. It was an honor to serve the country. All males aged 21 to 30 registered for the draft. Parades were held to escort the men to and from the depot. (Mary Bleiler.)

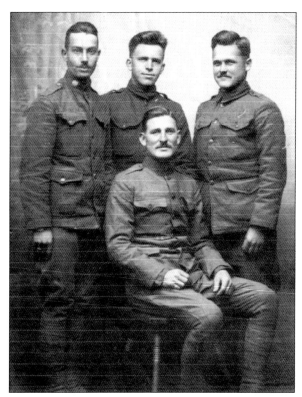

Herman Brandt from White Cloud is seen here standing at right. Brandt was killed in action on October 6, 1918, just 32 days before the armistice. After his death, a letter was found—he had written it to his sister, but it was never mailed—along with a short note to the family by the soldier who found the letter. (Jim and Diane Brandt.)

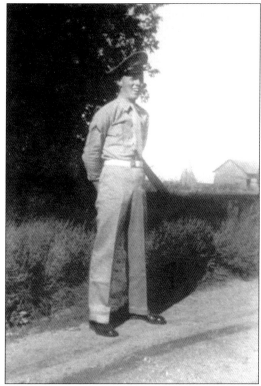

Everett Allen Dean Brooks is seen here as a US Marine. He was a World War II veteran. Brooks served four years as a radio message man and drill sergeant, serving part of his time on a submarine in the Alaska area, mainly in the Bering Strait. (Jan Smith.)

Cpl. Cecil K. Ringler of White Cloud served in the Army and was killed in action on January 9, 1943, while in New Guinea, at the age of 26. He served from 1940 until his death in 1943 and was awarded the Purple Heart. He is buried in White Cloud Cemetery. (Kathie Lewis.)

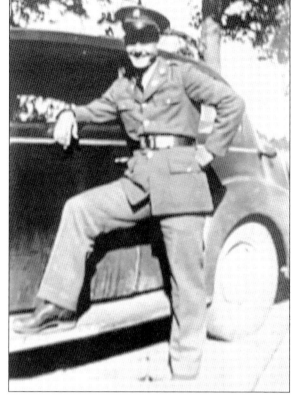

World War I veterans were the founders of the White Cloud VFW, organized under the name Sergeant Bowman Post 2053 in March 1931. In 1932, the post purchased the hall on the southwest corner of Wilcox Avenue and Barton Street. The VFW building was used for meetings and community events. (Bob Burke.)

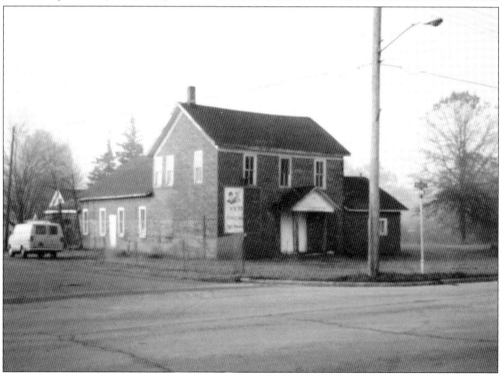

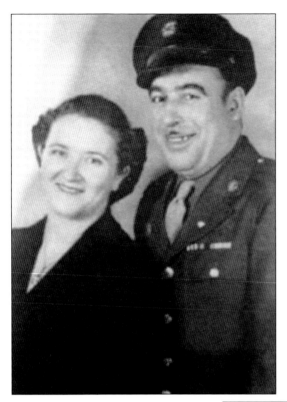

An all-out effort by all Americans was required when the United States entered World War II. Many women were required to run businesses when their husbands were called into the service, such as Anna Smith, pictured here with her husband, Charles. Many other women worked in defense plants, and some even ran service stations. (Jan Smith.)

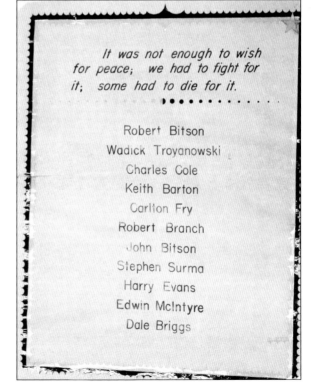

It was not enough to wish for peace; we had to fight for it; some had to die for it.

Robert Bitson

Wadick Troyanowski

Charles Cole

Keith Barton

Carlton Fry

Robert Branch

John Bitson

Stephen Surma

Harry Evans

Edwin McIntyre

Dale Briggs

This is a partial list of the White Cloud men who were killed during World War II. The list hung in the hallway at the old high school while Lyle Brundage was superintendent. Pat Ebenstein saved it and donated it to the White Cloud Library, where it now hangs in the history room.

The Korean War began in June 1950 and ended in July 1953. Many White Cloud men served. Some were drafted, while others enlisted. This was not a declared war by Congress, which seemed to set a precedent for other wars to follow. White Cloud lost one of its own in Korea, Orville Nyquist, on September 3, 1950. He was survived by his wife, Martha Nyquist Evans, and two children.

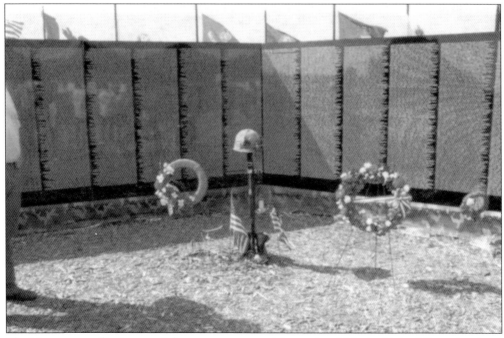

The Vietnam conflict is one of the most controversial wars in which the United States has been involved. Among the former White Cloud students killed were Doyle Holtzlander, Clifford Kelsey, Richard Frazier, and Richard Allen. One veteran stated: "We did not lose the war, we simply left."

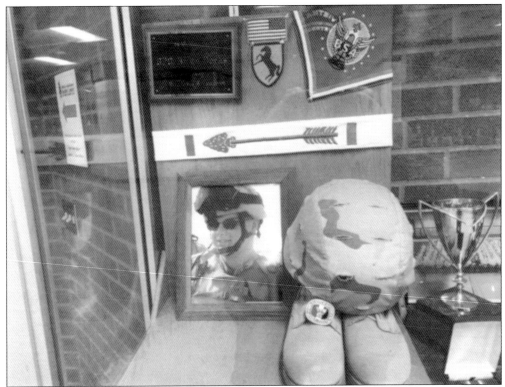

White Cloud men and women have answered the call to serve in many troubled areas since Vietnam. The Global War on Terrorism included US invasions in Iraq and Afghanistan. White Cloud's Brian Derks was killed in Iraq on August 13, 2005. (Bob Burke.)

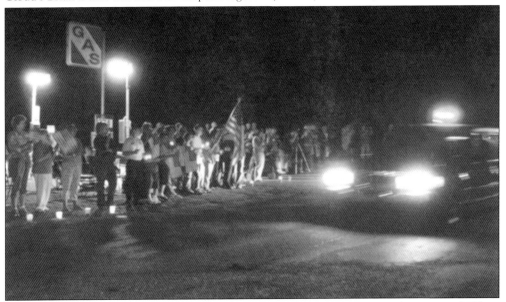

Brian Derks was born to Keith and Peggy (Willson) Derks. He grew up on a farm in rural White Cloud. After graduation, he enlisted in the Army. He fell in Iraq during Operation Iraqi Freedom on August 13, 2005. The whole town came out to welcome Derks home.

Five

M-37 NORTH

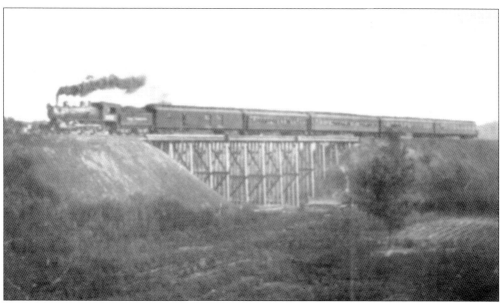

The White River and the railroad were channels for the lumber industry that gave birth to White Cloud. Traveling up M-37 to the north, on the east side of the road stands the wooden railroad trestle completed on September 29, 1875, that testifies to the time when the town was young. Many passenger and freight trains have passed over this trestle in its lifetime. (Rosie Alger.)

The Fry Brothers Super Station was on the northeast corner of Charles and James Streets. Brothers Clyde and Otis Fry operated the business in 1946. Pictured above on the bike are Glen Meyers (left) and Bruce Johnson. The Mobil station below was built in the same location as Fry Brothers; it was operated by Hank Niedzielski and was known as Hank's Friendly Service. In 1956, Harold Allers purchased the business, renaming it Allers Friendly Service. The station was one of eight places to purchase gas within the city limits in the 1960s. It is currently operated by Wesco. (Above, Lynn Gibson.)

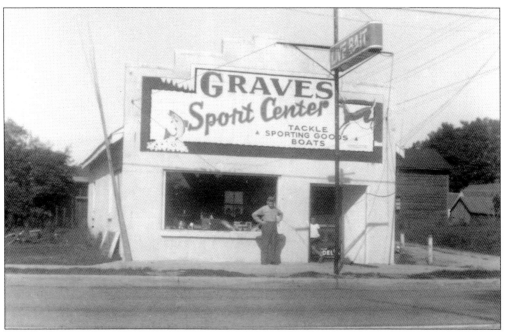

John and Ruth Graves built Graves Sport Center in 1949. The store offered live bait, licenses, hunting and fishing equipment, boats, motors, sporting goods, and free information. John's father, Walter, worked at the store while John worked his day job. Walter Graves is pictured here with his son Clinton. (Graves family.)

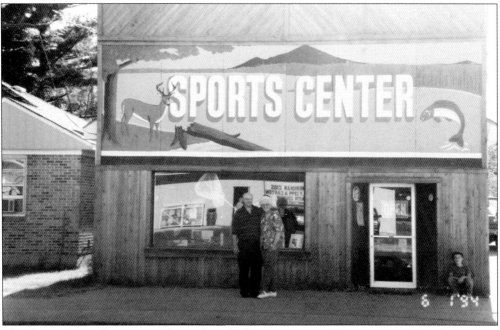

The Graves Sport Center sign changed, and additions were made to accommodate the growing business. Local children enjoyed the minnow tanks in the back of the store. Graves Sport Center was sold after 45 years in business. In 1994, it became Dave's Sport Shop and is currently Accurate Screen. John and Ruth Graves are pictured here along with their grandson Warren. (Graves family.)

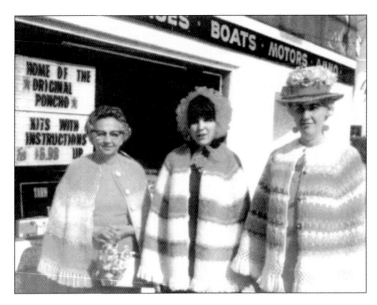

Ruth's Yarn Shop and Graves Sport Center shared the store space. Ruth Graves opened her yarn shop in 1962, offering imported yarns, patterns, knitting needles, crochet hooks, and later, fabric. Ruth invented the knitted poncho in the 1960s. Women came from all over Michigan to buy yarn and get expert knitting advice. Pictured here from left to right are Beulah Kintz, Cindy Graves Sharp, and Ruth Graves. (Graves family.)

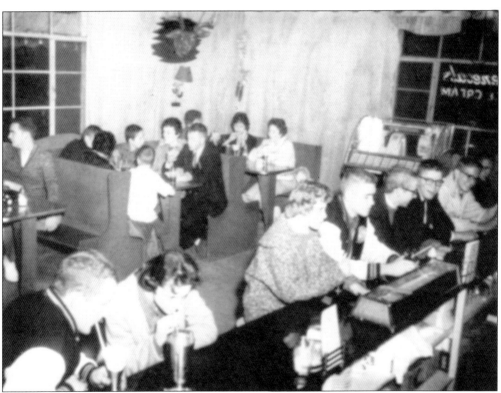

Peggy's Restaurant was a popular gathering spot for teenagers. If there was an event at school, the young people would hurry to Peggy's to save a booth for friends. The jukebox was popular, costing a quarter to listen to the latest records. Pictured at the soda bar are, from left to right, an unknown couple, Elaine Robinson, Bob Smith, Paul Johnson, Ed Jonaitis, and Ross Mast.

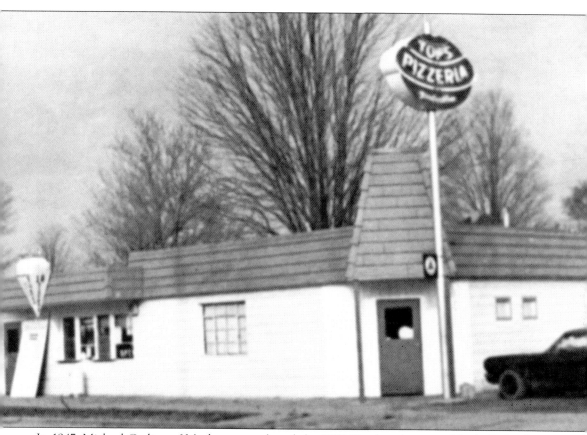

In 1947, Michael Carling of Muskegon purchased the G.W. Beach property and built Carling's Restaurant and Dairy Bar. In the late 1950s, Ken and Phyllis Crawford purchased the building, renaming it Crawford's Dairy Bar, or Ken's Dairy Bar. From 1961 until 1968, Roger and Peggy Mallette were owner/operators, renaming it Peggy's. From 1968 to 1975, the restaurant was owned and operated by Leslie E. Duke. He changed the name to Tops Pizzeria. George Cook also ran the restaurant for a time. In 1976, John D. Brown and Max C. Brown Jr. purchased it, changing the name to Brownerelli Brothers Restaurant and Bakery. In 1983, it was purchased by Rick Smith, who changed the name to Rick's Restaurant. Some of the favorite items offered over the years include chocolate malts, a pound of fries for a dollar, burgers, pizza, sub sixes, breakfast, and hand-dipped ice cream.

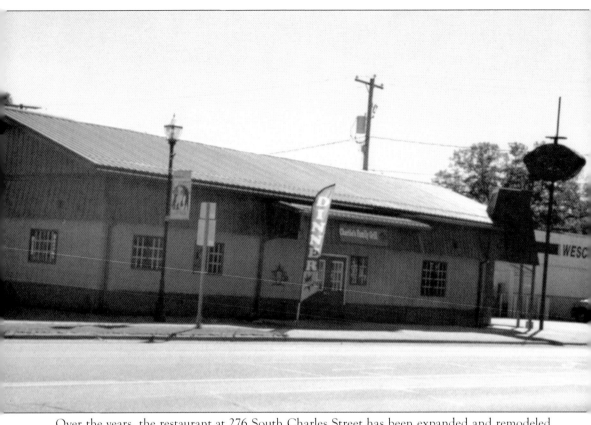

Over the years, the restaurant at 276 South Charles Street has been expanded and remodeled and changed ownership several times. It was purchased by Ray and Connie Eaton in 1986; they renamed it the Eaton House and served breakfast all day. Then, Ray and Mary Lou Cook bought the restaurant, renaming it C.A.R.S. It changed ownership again, becoming Nonno's Restaurant. George and Jeri Hitts, of Hitts the Spot Dairy Bar (at the corner of Wilcox Avenue and Gibbs Street), relocated here, renaming the restaurant Hitts the Spot Café. In 2021, the restaurant was purchased by David and Ryan Robinson. It was remodeled and updated and opened in 2022 under the name Charlie's Family Grill. This is the second location for Charlie's Family Grill; the original restaurant is in Fremont. This historic landmark was completely destroyed by fire on March 18, 2023.

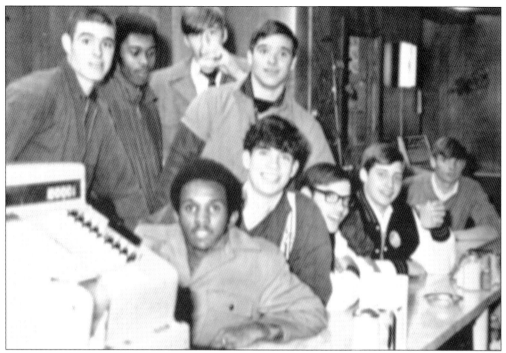

This picture shows the inside of Tops Pizzeria in the fall of 1969. These teenage boys squeezed together at the counter to get their picture taken. From left to right are (standing) Mike Smith, David Garrison, Dean Williams, and Sid Smith; (seated) Clifford Dukes, Don Barnhard, Ed Cruzan, Tom Rudert, and Richard Baumgartner.

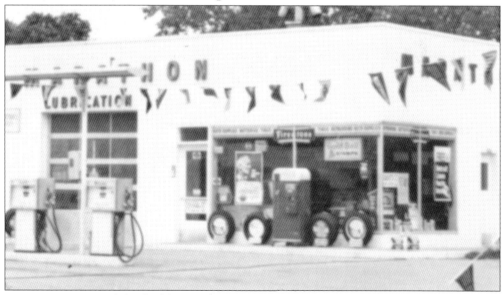

Les Tanis constructed this building, and it opened as the Speedway 79. In 1959, Ben Crofoot Sr. and Clayton Fetterley ran it as a Marathon service station. It was later operated by Ben Crofoot Sr. and Ben Crofoot Jr. In the mid-1970s, Weaver Oil of Fremont put in a self-serve Shell gas station. Wesco purchased a Subway franchise in 2005, and this location became the only fast-food restaurant in White Cloud.

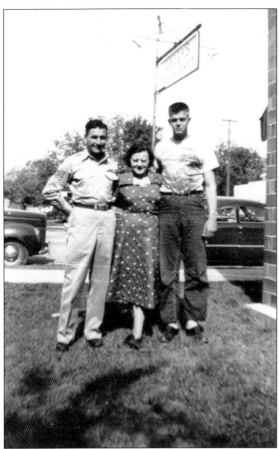

From left to right, Stanley Scheibach, Wanda Scheibach Putz, and Mark Putz are shown standing outside of Wanda's Restaurant. Wanda purchased the restaurant from Myrtle Lindquist in 1952, renaming it. In 1956, Art and Rena Perrin purchased Wanda's, expanding it to include the Starlight Cocktail Lounge, Adam and Eve's Gift Shop (on the south side), and Dave Hepinstall's Pharmacy (on the north side). (Mary Bleiler.)

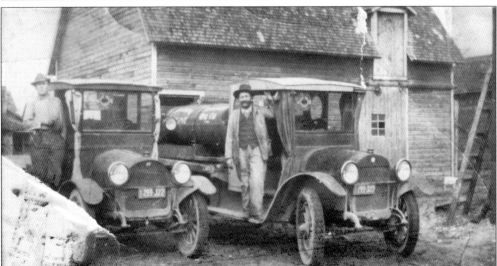

William Flaherty is shown standing on the running board of his delivery truck. Note the Standard Oil crown decals on the windshields of both vehicles. Glass crowns were later used on the top of Standard Oil gas pumps. Flaherty would later own the Standard Oil filling station along with the coal and ice business, including the icehouse at the Mill Pond. (Rosie Alger.)

This was William Flaherty's station, which also offered coal and ice for sale. It was purchased in 1940 by Barney Fowler and Andy Burke (pictured). The partnership lasted until 1954, when Fowler was named postmaster. The business then became known as Burke's Standard Service. Mac Slade and Ed Green kept the station supplied with products as well as delivering heating oil to homes. (Bob Burke.)

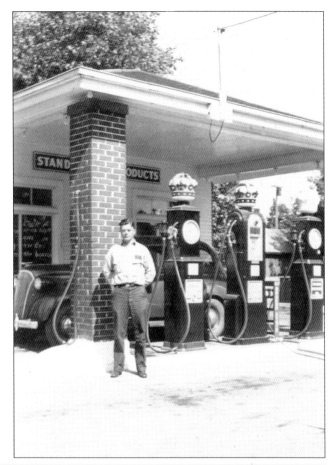

This photograph shows the old and the new. Construction on the new Burke's Standard Service was started in the spring of 1958 and completed later that summer. This new facility provided a wash bay along with other up-to-date equipment and improvements to accommodate the needs of the traveling public. The business was closed for less than two hours during the transition to the new facility. (Bob Burke.)

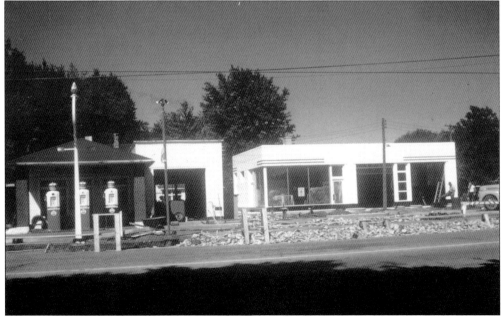

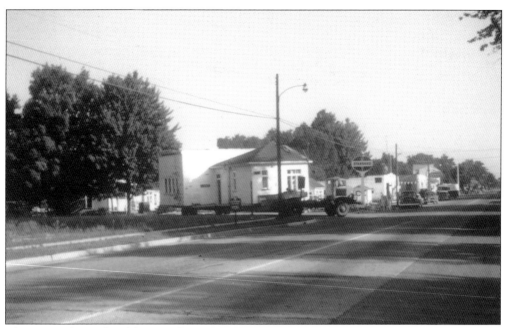

This image shows the old station being moved by Smith Movers of White Cloud. The building was taken to the southwest corner of West Echo Drive and Nicholas Avenue near Robinson Lake, where it was reopened as Robinson Lake Service Station. It was later destroyed by fire, and today, all that remains are memories of what was once at the corner. (Bob Burke.)

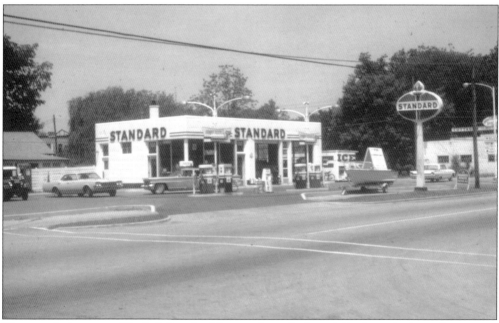

This was the location of Burke's Standard Service from the late 1950s through the mid-1980s. Ice was supplied by City Products of Grand Rapids. The proprietors during that time included Andy Burke, Bob Burke, Wayne and Jack Williams, and Mike Perrin. Today, this business is M37 Auto Repair, owned and operated by Jamie and Patti Steffes. The house at far left is where Parts Plus is now located. (Bob Burke.)

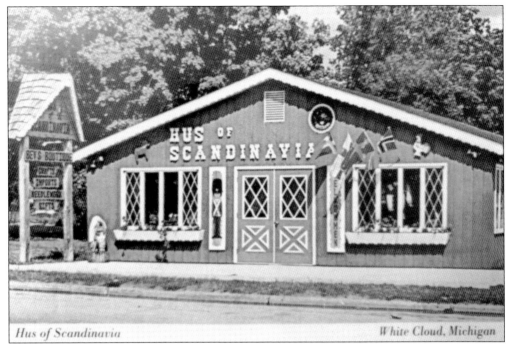

Hus of Scandinavia *White Cloud, Michigan*

In 1978, the VerSluys family built the Hus of Scandinavia, pictured here on Charles Street. The store offered beautiful items from that region of the world. Clarence VerSluys taught needlework classes, and Marlyn VerSluys tended to the store. In 1980, they added a two-story structure onto the back of the building. In 1988, they sold the building to enjoy retirement. (Clarence VerSluys.)

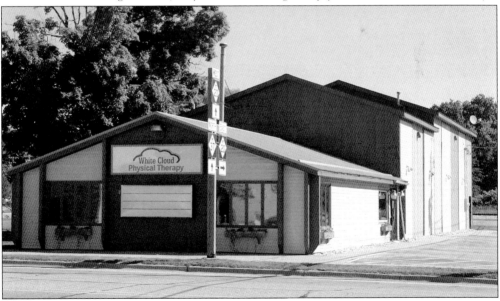

In 1989, the Feldpaush family operated a tropical fish and accessory business. It later became a fitness center. In 1994, Dr. Robert and Peggy Gunnell bought the building. Part of it was leased to Gerber Memorial Hospital for physical therapy. The Gunnells sold the building to White Cloud Physical Therapy in 2016, which also operates the fitness center. The fitness center has the only racquetball court in Newaygo County.

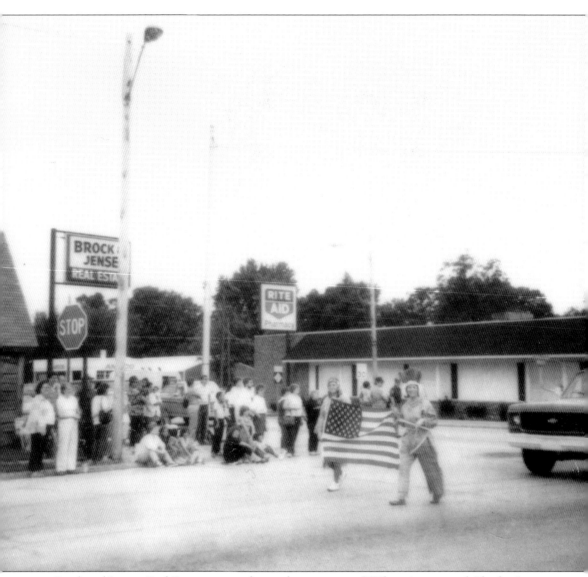

Brock and Jensen Real Estate was on the southeast corner of Wilcox Avenue and Charles Street, which is also the junction of two state highways. This photograph was taken during a Summerfest parade. In 1984, the building was sold to attorney Kevin Kozma, who practiced law there for 38 years. The law firm of Murphy, Caris, and Miller now owns the building. The Rite Aid building is in the background; this facility housed many grocery stores over the years, including Sander's Grocery in the 1930s, Charlie Ebenstein's Grocery in the 1940s, followed by Herb Eggerstedt's Corner Store, Lavern Swartz, and finally Irv Crawford's Grocery in the 1970s. Lyle Mitchell also had an appliance store there in the 1940s. Dale Voss and Associates purchased the property in 1980 and brought in Lipperts Pharmacy in 1981 after renovating the store. A few years later, it became the Rite Aid. One of the last businesses on this site was an antique store. The building is currently empty.

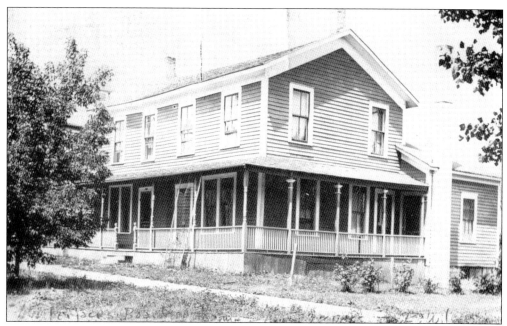

This boardinghouse was on the northeast corner of Wilcox Avenue and Charles Street. It is said that it was an old building in 1910, when C.E. and Gertrude Cooper moved to White Cloud. The house was maintained by a lumber company for its lumberjacks.

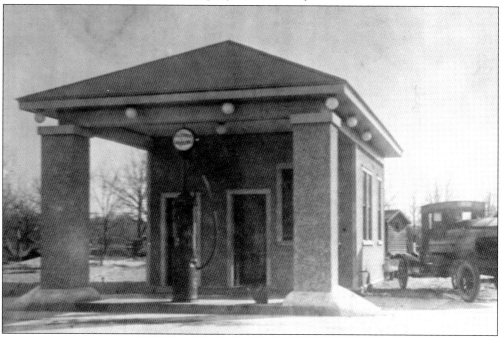

In the late 1920s, Charles Decker erected a Peerless Oil Company station on the northeast corner of Charles Street and Wilcox Avenue. He sold Superior Gas from this location. Other businesses at this site included Charles Decker Implement Store, Mike's Sinclair, Marvin Deur's Sinclair, White Cloud Arco, a used car lot, an insurance office, and a flower shop. It is now the White Cloud Welcome Center.

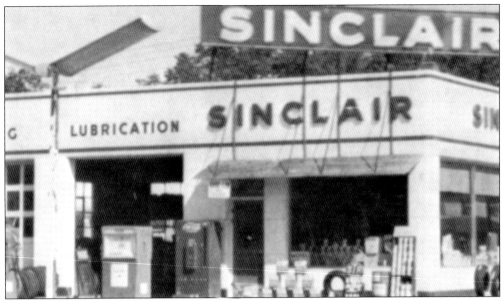

Mike Eggerstedt opened the Sinclair station on December 23, 1949. This was the first station of its type to be built by Sinclair Refining Company. Eggerstedt was told that if this station met their expectations, it would be the model for stations in small towns throughout the state.

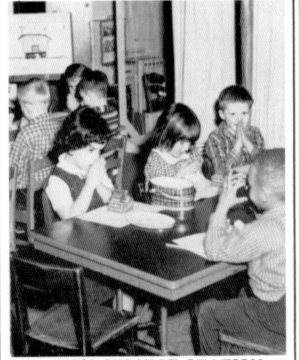

"Counting Our Blessings"

MIKE'S SERVICE STATION
MIKE EGGERSTEDT, Prop.
Phone 2751

Nearly 10 years after Mike Eggerstedt opened his gas station, he placed this advertisement in the 1959 *Chieftain* yearbook. In October 2005, a ribbon-cutting ceremony was held on this corner for the White Cloud Welcome Center, which was part of a massive rejuvenation of Wilcox Avenue.

This photograph shows a young couple at the side of the Kom Bac Inn around the mid-1940s. The restaurant was owned by Ann Stanley. It was a popular spot for breakfast, lunch, and dinner. It was in the Rudy Johnson building on the northwest corner of Charles Street and Wilcox Avenue. Employee Adah Stroven later bought the business, and Julia Ruttkowski helped run it. (Lynn Gibson.)

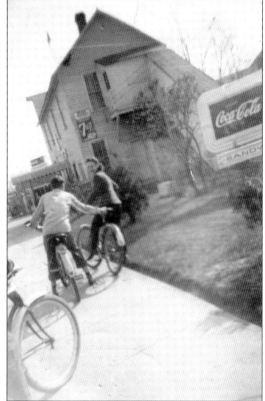

Rudy Johnson's building was on the northwest corner of Wilcox Avenue and Charles Street. This building saw many businesses in its 100 years, including Bird's Grocery in 1910, and several restaurants. The building was demolished in the early 1980s, along with the *Eagle* office and a residence, to make room for the new Rudert Agency Insurance.

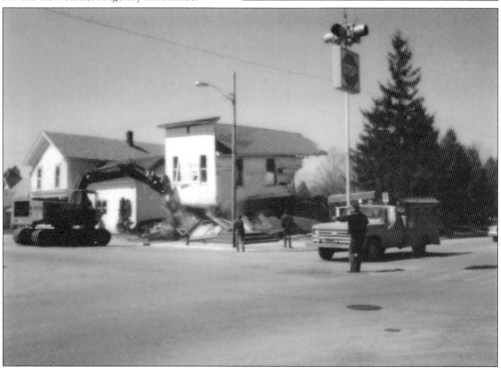

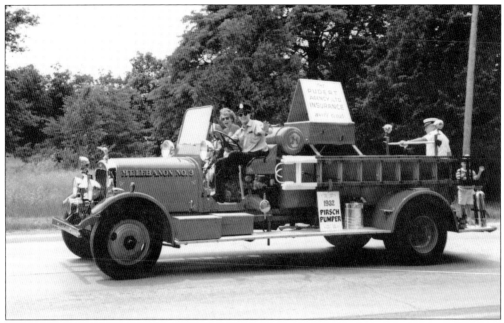

In 1954, Donald Rudert started Rudert Agency Insurance out of his home on James Street. He purchased this antique 1932 Pirsch Pumper from Mt. Lebanon, Pennsylvania. Driving is Donald's son Eric, and sitting up front is Eric's mother, Norma, who is waving to the White Cloud parade crowd. Don Rudert is standing on the back of the truck in his White Cloud Fire Department dress uniform. (Graves family.)

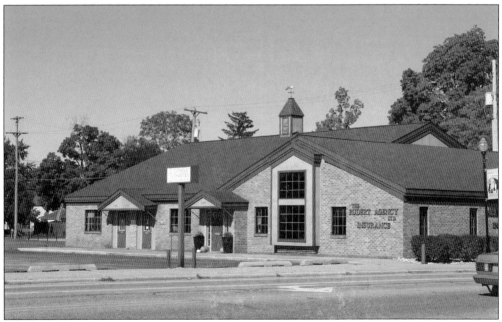

In 1985, Donald Rudert constructed this building for Rudert Agency Insurance. The corner was paved for a parking lot. Eric Rudert joined his father's insurance business. In 2019, Rudert Agency Insurance joined the Keyser Insurance Group, led by Chris Fisher. The Catholic Charities of West Michigan is located in the west end of the building.

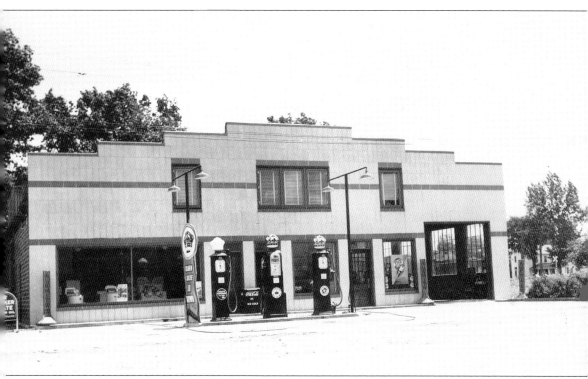

Charles Moore's Dodge and Plymouth dealership was on the east side of M-37, a half block north of Wilcox Avenue. The original building was destroyed by fire in March 1938. The business was rebuilt on the same site and included a repair bay. The gas sold was Standard leaded, Red Crown, and Solite with Ethyl. The new building was 62 by 70 feet, with a 12-foot ceiling. It had a 22-by-30-foot basement, which housed steamed heating. There was a second story that had a five-room apartment where the Moores lived until their retirement. The building was sold to Marvin Deur in the 1970s, and the north end was leased to Maike's Bakery (later becoming the White Cloud Bakery operated by the Stencel family). There was also a laundromat in the south end of the building owned by Marvin Deur. In 1989, Dale and Dolly Voss purchased the building, keeping the laundromat on the south end and using the north end as their business office. Today, this is a vacant lot.

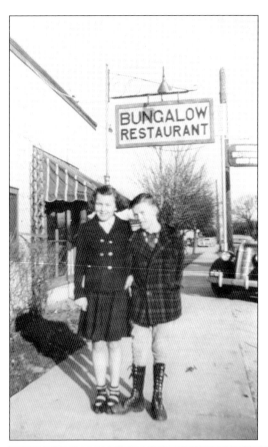

Pictured in the late 1930s are Joan Putz Bleiler and Mark Putz standing outside the Bungalow Restaurant, which was run by their grandparents Steve and Katherine Scheibach. Katherine Feighner Scheibach and George Feighner worked in the restaurant. The Scheibachs sold the Bungalow to John and Jeanette Loeks in 1945. (Mary Bleiler.)

The address of the Bungalow Restaurant is 157 South Charles Street. In the early 1900s, it was Perry Williamson's barbershop. The barbershop later moved to Wilcox Avenue. Around 1910, Albert and Ida Schurger opened Schurger's Bakery at this location. It later became the Bungalow Restaurant under different owners. The restaurant sat empty for quite a while before becoming Maike's Bakery in 1984. (Suzie Fetterley.)

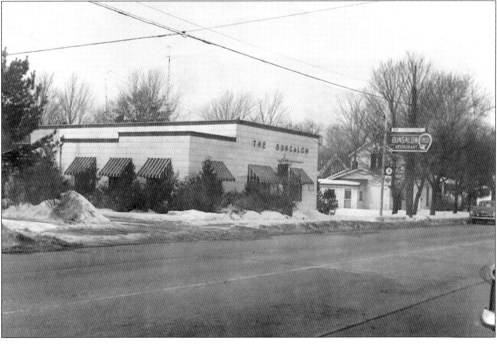

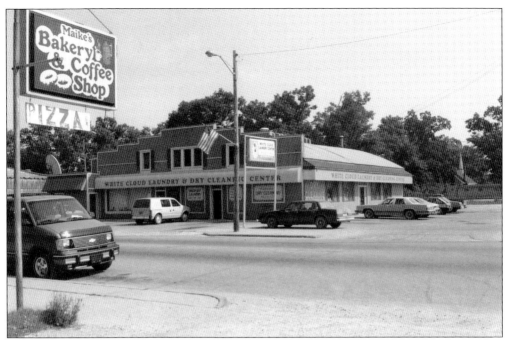

The White Cloud laundromat served this community for many years beginning in the 1970s. It was owned by Marvin Deur, who sold the building to Dale and Dolly Voss in 1989. The north portion of the building was used as an office for the Vosses' businesses, and they kept the laundromat at the south end. It closed in 1999. (Suzie Fetterley.)

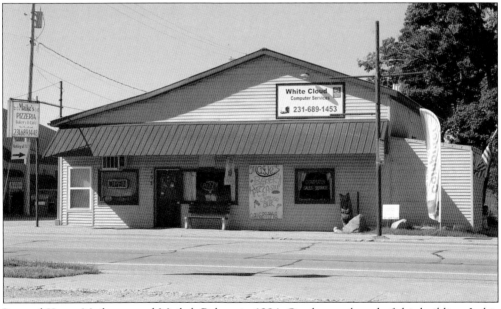

Jim and Karen Maike opened Maike's Bakery in 1984. On the north end of this building, Jackie Bulson had a flower shop. The bakery expanded after the flower shop closed, and it became Maike's Bakery and Pizzeria. Ryan Maike started White Cloud Computer Sales and Service in 2002, relocating the business inside the Maike building in 2008. Ryan Maike is currently the owner of the building and computer business.

Rood Real Estate was located at 145 Charles Street. Reo and Josephine Rood had an A-frame modular kit home built for a display model on the corner just north of this office. Lisa Westcomb operates Bucky's Barber Shop from the original real estate office, providing services for men and women for over 17 years.

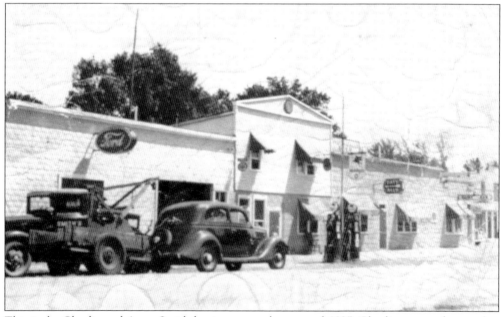

This is the Charlie and Anna Smith business complex around 1935. Charlie operated a wrecker service, an auto repair garage (which included welding), and a Mobil gas station. There was a dairy bar on the south end of the building. Charlie also operated a Ford dealership and was the first naturalized citizen in Michigan to do so. (David Smith.)

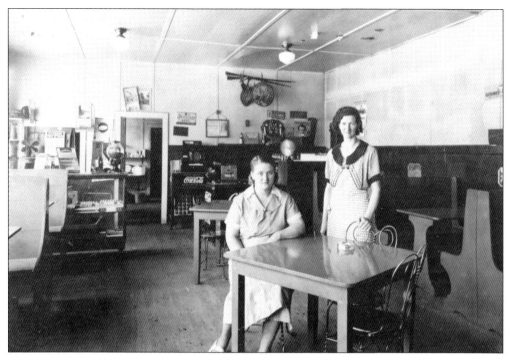

Anna Smith (left) and Angie Schondelmayer are pictured inside Smith's Tavern in the 1930s. The tavern served beer and was known for its excellent hamburgers. There was a dairy bar at the south end of the building. The Smith family lived in an apartment above the tavern. Anna Smith was the first woman to have a tavern license in Michigan. (Smith family.)

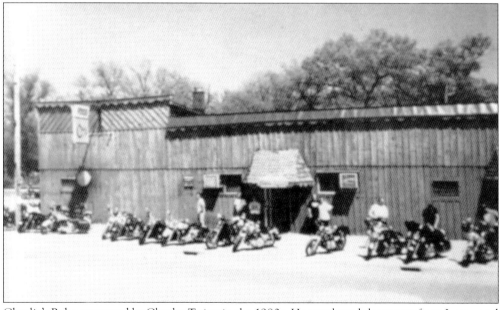

Charlie's Pub was owned by Charles Twing in the 1980s. He purchased the tavern from Lenny and Dottie Smith and sold the business to Kathy Reid and Rose Harrington in 1987. They owned the bar and restaurant for 28 years, closing it in 2015. In 2017, Annie Schnieder and Kasey Hershberger purchased the property, which now houses AKJ Fireworks. (Kathy Reid.)

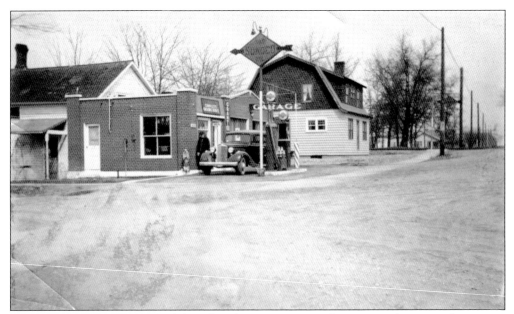

Martin's Sunoco station was built by Bill and Georgia Martin about 1933. The Martin home next to the station was built at the same time. It was a Sears, Roebuck and Company kit house. Bill Martin is pictured with his dog Spot. The house was later moved to the corner of Pine Hill and Gibbs Streets to make room for parking. (Suzie Fetterley.)

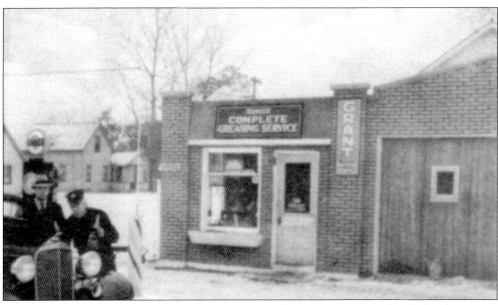

Bill Martin is dressed in a Sunoco uniform and pictured servicing a customer's vehicle—this service included pumping gas, checking the fluids, checking the tire pressure, and washing the windshield. This customer happens to be White Cloud resident, businessman, and state representative Clyde E. Cooper. (Suzie Fetterley.)

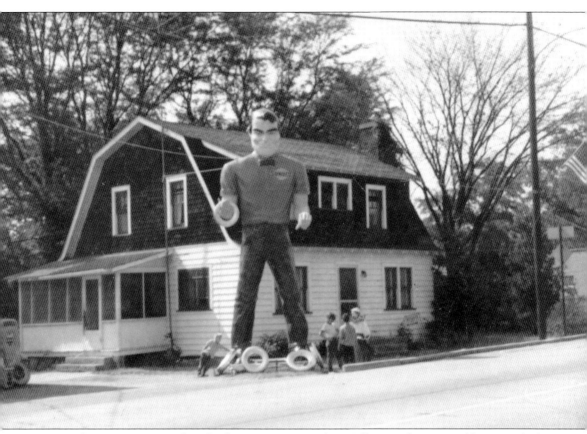

Around 1961, Len Harper bought the Sunoco station from Bill Martin's son Harold. Harper had the service station until 1966. This photograph features a giant Sunoco advertisement promoting free cotton candy for customers. Len Harper Jr. is to the left of the man (the other people are unidentified). Around 1967, Clyde Lovell bought the business and renamed it Lovell's Sunoco. Clyde and his son Larry ran the busy full-service gas station for over 10 years. Edwin Jarvi purchased the business in 1978, followed by John Larsen, Walter Felos, Dick Alexander, Charles Pummel, and Billy Westgate, to name a few. Presently, John Schneider owns and operates Schneider Service Center. Schneider recently put a large addition on the building, giving it a much-needed facelift. Schneider hopes to one day sell gas, making it a full-service station. (Len Harper.)

The White Cloud Chiropractic Center was on the south end of a double office building on Charles Street. Dr. Howard Palmer started the White Cloud Chiropractic Center in 1961. His son Terry joined the practice in 1969. Dr. Terry Palmer opened his own practice in 1971 in Hesperia. Dr. Damian Palmer is the third generation of chiropractors serving White Cloud and Hesperia.

Myrtle Basford was the realtor at the Branch Real Estate Office in the 1950s and 1960s. James Champion and Charles Foster worked for Basford as agents selling resort and residential properties. Margaret Fowler worked as a part-time secretary. This building has housed many businesses. In 2013, Dan Abid purchased the building and started the White Cloud Tobacco Store.

In the 1950s, the Drive Inn restaurant was owned by Karl and Doris Eldred. It then was sold to Clyde and Margie Lovell in 1960. It was owned by Hazel Worm from 1963 through 1965. The business was called the Drive Inn throughout these three ownerships. Wally and Sally Felos were the next owners, renaming the restaurant Sally's Drive Inn in 1966.

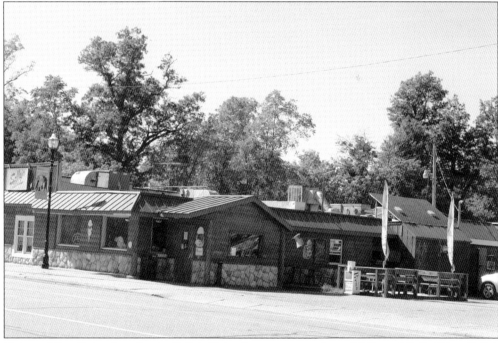

Dale and Sue Twing bought the Sally's Drive Inn restaurant from Wally and Sally Felos. Sally's was well known for its cinnamon rolls. The next owners were Joe and Idalee Harner. Dale Twing returned to the restaurant after Joe Harner's death. He was in a partnership with Idalee Harner and Jim Hines. Dan Abid was the next owner, adding What-A-Pizza into the mix. Pauline LaBelle currently operates Trail Town Restaurant at this location.

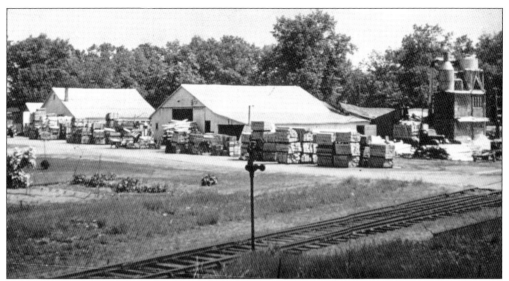

Briggs Lumber Company was established in 1930 by O.J. Briggs and his father, Z.J. Briggs. It began with a portable sawmill making crossties for the railroad. In 1931, the business rented a lot on Swain and Benson Streets from Mac Slade and set up a permanent sawmill next to the railroad tracks.

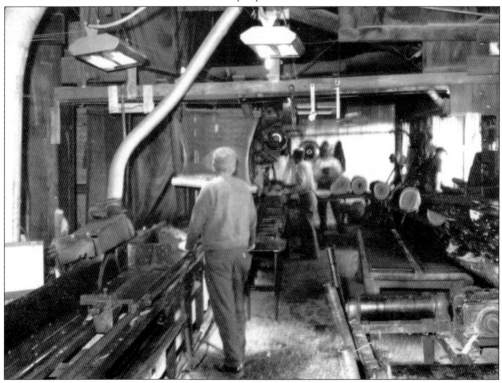

Briggs Lumber Company changed into a construction business, including prefab homes, from 1945 to 1947. The temporary prefab homes sold for $1,500 to returning veterans. By 1949, the business started producing pallets, boxes, and crates. In 1950, O.J. Briggs Lumber Company was incorporated with O.J. Briggs as president, Ellroy Richardson as general manager, Lyal Zimmerman as sales manager, Otis Fry as plant manager, and Leon McGowen as accountant. (Briggs Lumber Company.)

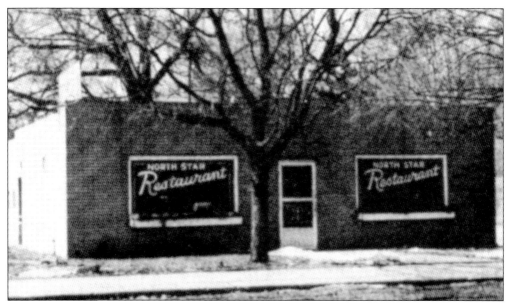

The North Star Restaurant was on Charles Street in the northeast corner of the present Houseman parking lot. It was operated by Wanda Putz in 1947 and later owned and operated by Robert and Ruth Fisher, Rosie Lovell's parents. Other businesses at this location included Kay Twing's Sign of the Eagle antique shop, Regional Health Office, and I-Scream.

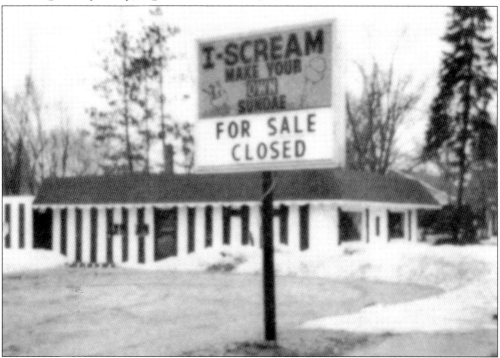

I-Scream opened around 1980. It was owned by John and Phyllis Crisman. Ice cream was dished up into miniature Major League Baseball helmets of a customer's choice. The self-serve topping bar had every topping imaginable. Old and young folks came in hoping to collect the whole set of helmets. The Crismans flew a large US flag above the store. (Crisman family.)

White Cloud Manufacturing was at 19 North Charles Street. Jack and Fred Benedict of Big Rapids purchased this building in 1962 for use as a steel sand-casting foundry. In 1963, the foundry was transitioned into a bronze sand-casting facility to supply US Navy shipbuilding programs with bronze hose fittings. They also supplied parts for Apache helicopters and nuclear submarines. The business was renamed in the 1990s to Bentek. In 2001, Tom Benedict purchased Bentek from his father, Jack, and his uncle Fred Benedict. Tom erected a new building around the old structure. After the new building was completed, the old one was demolished and removed. In 2016, Tom Benedict sold the business and retained ownership of the building. This factory employed many White Cloud residents.

Houseman's Foods opened this store in August 1997. It is located where the original O.J. Briggs Lumber Company and the former I-Scream shop once stood, north of the Trail Town Restaurant on M-37. Houseman's Foods was originally on the northwest corner of Wilcox and Benson Streets and was formerly Bird's Grocery Store. Jeff Houseman ran the business until 2015, when it was purchased by Jon Hammersley.

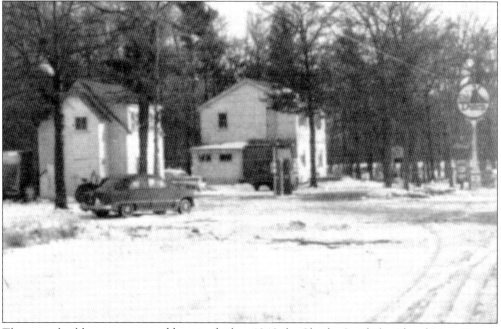

These two buildings were moved here in the late 1940s by Charlie Smith for Al and Mary Kymes. They were on North Charles Street across from the airport. The building at left is the old Dutch gas station. The building at right was once the Fulkerson School. A second story was added to the school building and rented to the Fraternal Order of Eagles. Around 1966, it became Becker's Hilltop Store.

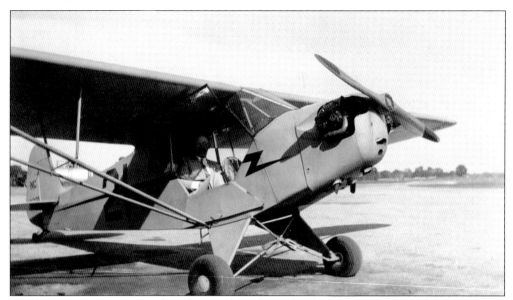

Charlie Moore is pictured in his plane at the White Cloud Airport. Charlie and his wife, Rita, would fly to Detroit to buy a new car for a customer. Charlie would fly the plane back to White Cloud and Rita would drive the new car back.

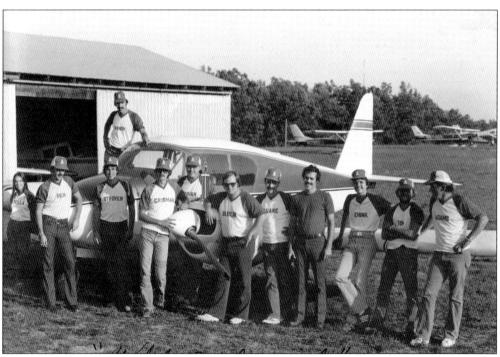

In October 29, 1929, Newaygo County purchased the airport property for $1 from a trust made up of 10 businessmen. In 1970, the trust sold the property to the City of White Cloud for $1. E.J. Jones was instrumental in making the airport what it is today. The 1977 "Slo-Pitch Champs" pictured here were sponsored by the White Cloud Airport.

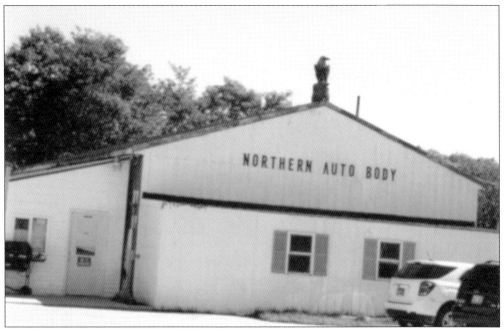

Northern Auto Body is located at 304 North Charles Street, across from the airport. Chip and Dan Wiersma, the co-owners, have been serving the White Cloud area for the last 25 years. They specialize in collision repair, painting, and rust and restoration projects for all makes and models of automobiles.

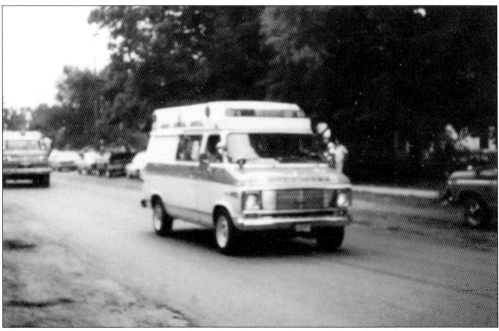

This picture was taken during the White Cloud Summerfest parade in the early 1980s. The orange stripe on the ambulance meant that the vehicle, staff, and equipment met the 1971 federal guidelines. Gerber Memorial rural ambulance service was the first rural advanced life support system in the United States. The White Cloud Fire Department housed ambulances for 20 years. (Cindy Sharp.)

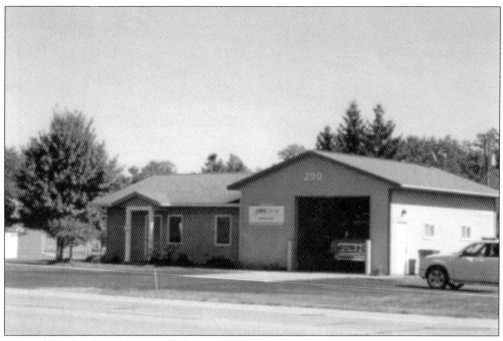

This is the White Cloud station of Life Emergency Medical Services at 290 North Charles Street. Life Emergency Medical Services offers air and ground ambulance services. In 1992, Gerber Memorial Hospital purchased the home and later built the ambulance garage. In 2005, Life Emergency Medical Services purchased the building from Gerber Memorial Hospital.

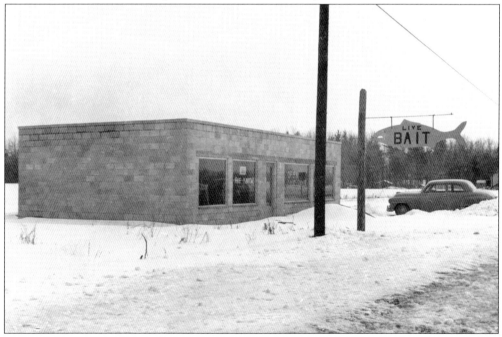

This is the bait shop at the northern city limits in White Cloud. It was operated by Ray Richards of Long Lake and was also used as a pool hall. In the mid-1960s, Patrick Salisbury and Ronald Sanders started Salisbury and Sanders Survey, purchasing the building from Joe Levine. (Harry Hooker.)

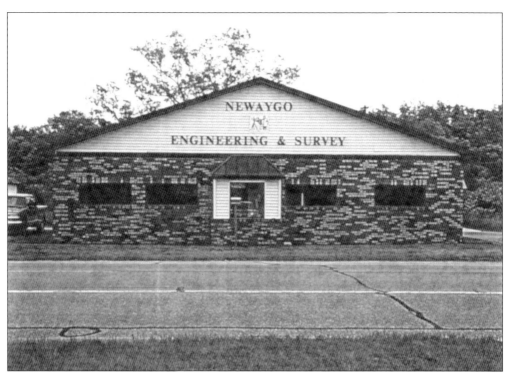

Newaygo Engineering & Survey is currently owned by Patrick N. Johnson, who purchased the building and business from Norman Ochs, Newaygo County surveyor, on March 1, 2018. Ochs held that position from 1977 until his death in 2019. Ochs worked for Pat Salisbury and then Richard Kraft before purchasing the business from Kraft in 1986.

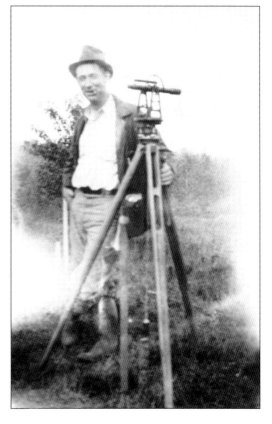

Pictured here is Lyle Shepherd, who served as the Newaygo County surveyor from 1914 to 1949. Other county surveyors included William Jacques (from 1903 to 1914), Ralph Smith (1950–1966), Patrick Salisbury (1967–1976), Norman Ochs (1977–2019), and Gerald Nordlund, who finished Ochs's term from October 2019 through 2020. The elected position was eliminated in Newaygo County at the end of 2020. (Newaygo Engineering and Survey.)

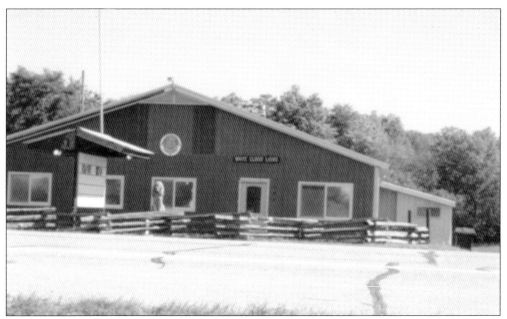

The White Cloud Lions Club is located at 294 North Charles Street. The club was formed around 1972 and has been serving the community for over 50 years. The Lions Club building is available to rent for multiple uses and community events. The club serves local children and schools through scholarships, recreation, and mentoring, and offers services like diabetes screenings, vision screenings, and eyeglass recycling.

The city limits sign on M-37 at the north end of town is at the entrance of the industrial park. The ribbon-cutting ceremony for the industrial park was held on July 18, 2003. The park has paved streets, water and sewer service, and streetlights. There is a railroad spur in the park. The White Cloud Fire Department and the Ceres Solution Cooperative Inc. feed mill are located in the industrial park.

Six

A WALK AROUND TOWN

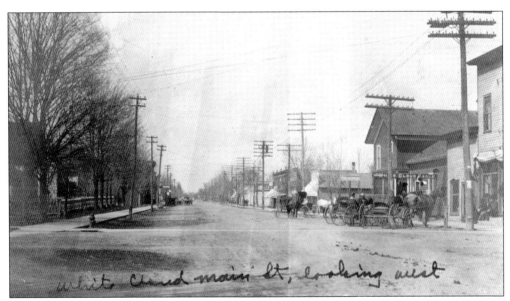

white cloud main st, looking west

Most of the streets in White Cloud were named after the town's founding fathers. The main street running east and west is Wilcox Avenue, named after lumber baron Sextus Wilcox. Lester and Morgan Streets were named after lumber baron Lester Morgan. Charles and James Streets were named after Lester Morgan's sons. Gibbs Street is named after developer J.M. Gibbs. Court Street was where the first jail was originally located.

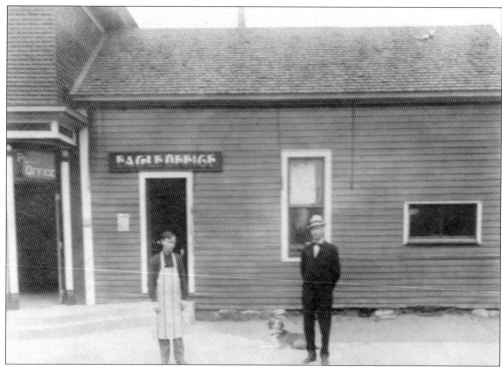

In 1898, Lewis Fuller started the *White Cloud Eagle*; he was followed by H.W. Morley, who ran the newspaper until it was sold to Clyde Cooper in 1910. Clyde's son Jac bought the paper in 1943. The *Eagle*'s competitor, the *White Cloud Star*, was incorporated into the *Eagle* in 1918. In 1942, at 82 years old, Fuller returned to work at the *Eagle* as a compositor. In 1972, the *Eagle, Grant-Herald Independent*, and *Newaygo Republican* were purchased by Pioneer Publications of Big Rapids. Pictured below in 1927 are, from left to right, Jane Cooper, Nick the dog, Clyde Cooper, Ed Burke, Jac Cooper, Carl Green, and Erma Branch.

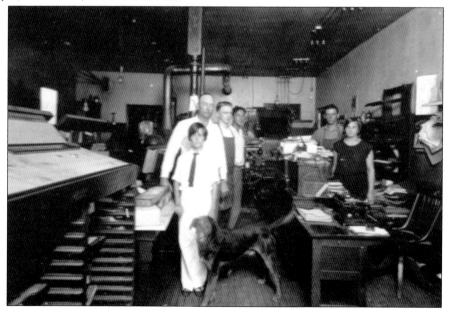

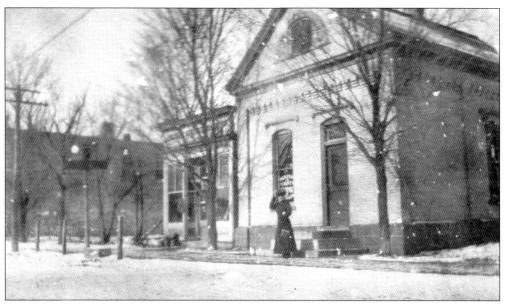

In 1902, Newaygo County Bank was established by Fred Woods Riblet, cashier Lewis Fuller, and B.C. Sickles in the Old Exchange Bank Building (where the post office is now located). In 1906, this bank was robbed. The robbers made off with over $2,000. In 1926, the bank closed, with accounts being taken over by the Old State Bank.

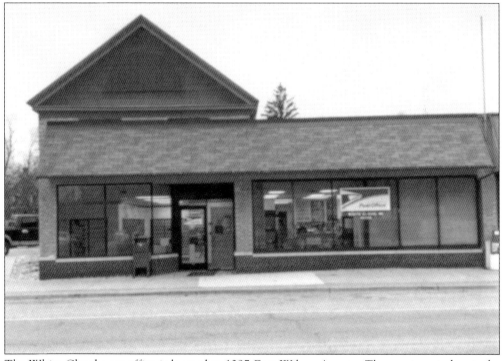

The White Cloud post office is located at 1097 East Wilcox Avenue. The service window is the former Pettit's Five and Dime, followed by Richard and Martha Evans. The postal box section is in the former Fuller Bank. The current post office location is one of six, with the first two in the area of North and Adda Streets and the last four on Wilcox Avenue.

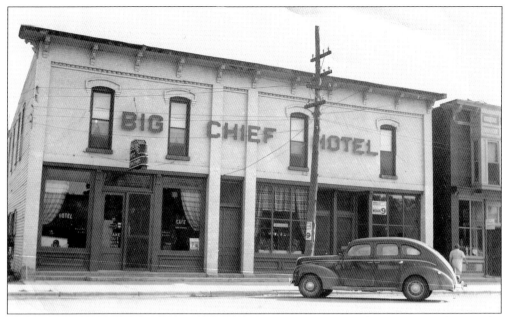

J.C. Townsend erected this building in the mid-1890s. It was constructed for commercial use on the first floor with apartments upstairs. It later became the Big Chief Hotel, with a fine-dining room and bar area. The hotel and bar business ended in the early 1960s. Howard LaCourse bought the building in the 1970s and opened a game room named Howard's Hobby Hut.

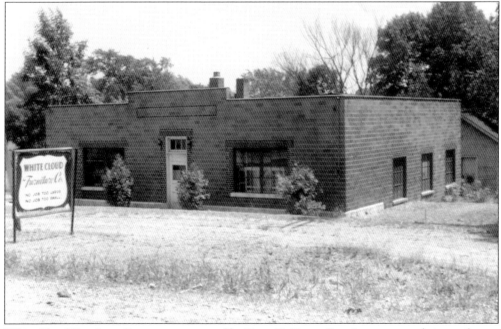

White Cloud Furniture Company was owned by Casey DeKorne. Furniture parts and picture frames were fabricated here. It was located on the southwest corner of State and James Streets. Previously, the power plant was located here, north of the water raceway. This building was destroyed by fire in the 1970s.

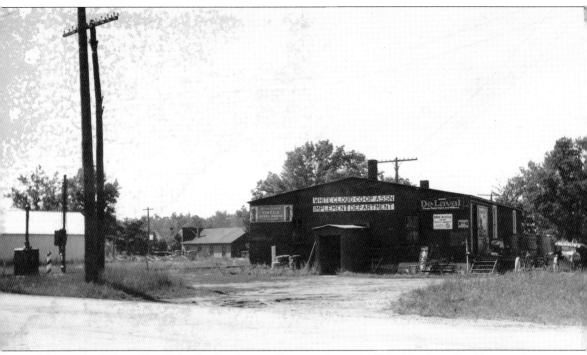

This is the White Cloud Co-Op Implement Store in the mid-1930s. The large building in the background with the false front was Moore's Garage, which was destroyed by fire in March 1938. The co-op store was on the north side of Wilcox Avenue east of the railroad tracks. This facility was used until the early 1990s, when a new store was built on the south side of Newell Street one block south of the original location. Among those who worked at the store are Al and Wayne Stuthard, Helen Balluff, Doris May, and Barb Taube. North of the building—but not shown here—were large fuel storage tanks owned by Standard Oil. Just east of the tanks was a barn used to store Standard Oil products. Mac Slade and Ed Green were the Standard Oil agents.

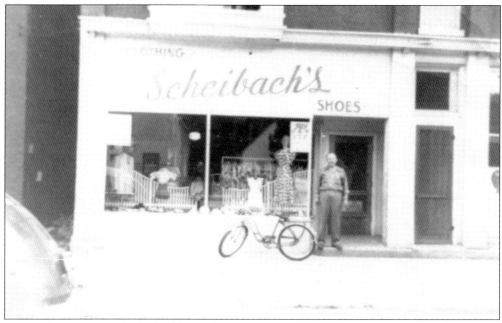

Steve Scheibach started Scheibach's Ready to Wear in the 1950s. Scheibach was the third mayor for the city of White Cloud. The store specialized in work clothes and boots. The location of the store later became the second building that housed the public library. The building was between the Big Chief Hotel and Bill Brandt's barber shop. (Steve Scheibach.)

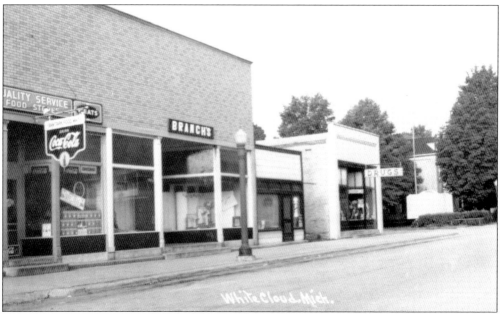

Pictured here are (left to right) Carl Anderson's grocery store, which later became Dave's pharmacy (owned by David Hepinstall), Wells and Margie Branch's Dry Goods, Ted Branch's barber shop (which was shared with Elsie Tanis's beauty shop in back), and LeMire's drugstore, where Alvon LeMire was the pharmacist in the 1950s. The building on the corner burned down in 1985.

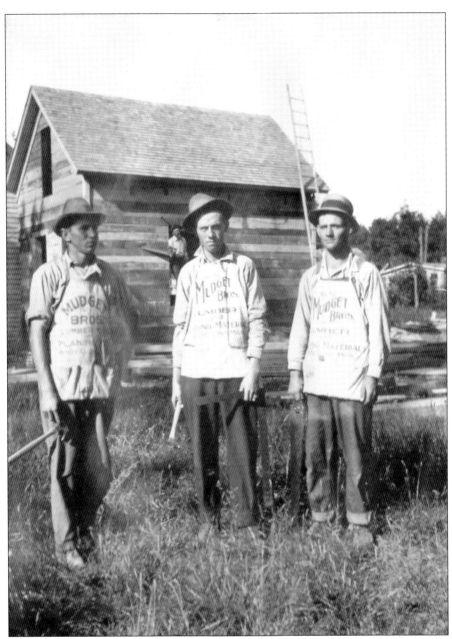

Rolla Ashcroft sold his successful lumber business in August 1911 to brothers R.A. and Foster Mudget. The Mudget brothers continued to provide construction supplies to the growing community. A bundle of shingles cost $1.65, and a sack of land plaster (cement) was 25¢. The Mudget brothers were fur buyers for the 1910 fur season and traveled to numerous county locations. They would be in Bitley on Mondays, White Cloud on Tuesdays, and on the road on Wednesdays. On Thursdays, they were at Holland's store in Woodville. On Fridays, they were at W.E. Fulkerson's store in White Cloud, which was their headquarters, and they came home on Saturdays. They claimed to pay the highest market price in the area. The Mudget brothers had a sense of humor in their newspaper advertisements, including one that read "REBMUL TSEB EHT" (telling people to read it backwards). The Mudget family was very supportive of community fundraising events. (Suzie Fetterley.)

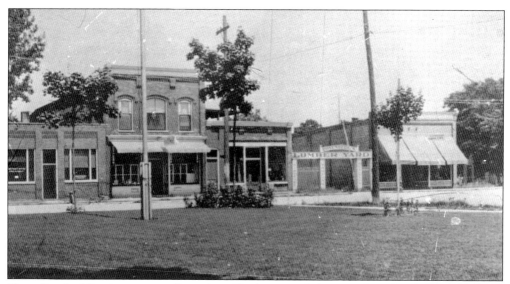

The tallest building in town was Rosenberg Hardware, and the Rosenberg family lived above the store. This photograph was taken around 1900. At that time, Rosenberg's also had a lumberyard. During World War II, Getty Rosenberg worked at a hardware store in Muskegon and in a factory producing war materials. Getty's wife, Zella, managed the White Cloud business. (Rosenberg family.)

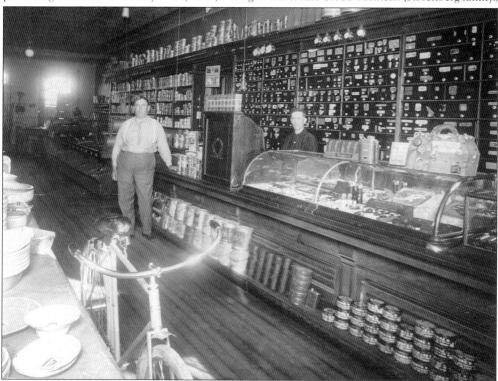

George Robert Rosenberg (left) and Getty Lee Rosenberg are pictured in 1910. George Robert was a timber buyer for Ryerson-Hills Lumber Company of Muskegon. He purchased the hardware business from A.Q. Adams. Getty Rosenberg took over management of the store in 1916 after his father's death. (Rosenberg family.)

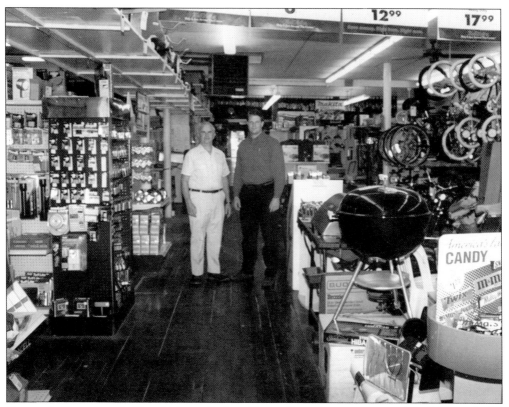

George A. Rosenberg (left) and his son Robert George Rosenberg are pictured in 1993 inside the original store. Robert George is the fourth generation of Rosenbergs to have owned and operated the hardware business. Robert George's son Eric is part of the fifth generation, and he has two sons of his own. (Rosenberg family.)

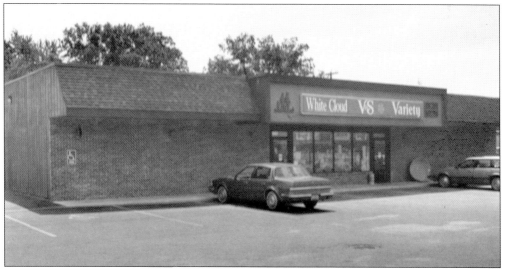

In 1988, Rosenberg V&S variety store opened as a separate business from the hardware store. In 1994, Rosenberg Hardware merged with Rosenberg V&S at the same location and moved to a new location to the east on the south side of Wilcox Avenue. (Rosenberg family.)

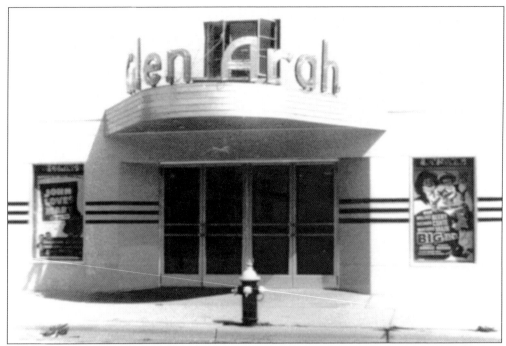

In 1948, Glen and Arah Beach built a movie theater. The latest features were shown, including afternoon matinees and midnight movies. The theater closed in 1955. The Assembly of God Church bought the building and worshipped there for many years until moving to a building on Fortieth Street. Currently, this building is the home of the Stage Door Players. (Laurie Deater.)

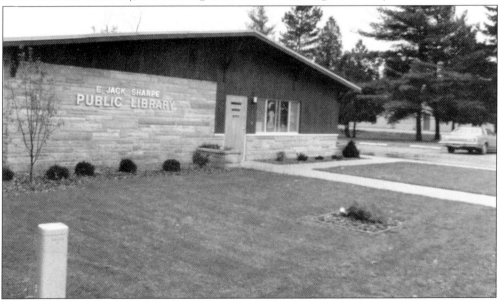

White Cloud's first library opened in 1955 at 1055 Wilcox Avenue. In 1959, the library moved to 1146 Wilcox Avenue. In 1977, E. Jack Sharpe purchased the Kroeze Funeral Home and moved the library to 1038 Wilcox Avenue. In 1997, an addition was put on, doubling the size of the library. Martha Evans worked hard to put together the Local History Room, which houses Dr. Sidney Douglass's collection.

In 1939, Crandell and Ensing of Fremont bought Reeds Funeral Home in White Cloud, with Jack Crandall overseeing the business. In 1959, a new chapel was built at the same location by Cruzan Brothers. In 1979, the business was incorporated as Crandell Funeral Homes Inc. In 1996, a large addition was completed. For 84 years, the Crandell family has served the people of White Cloud.

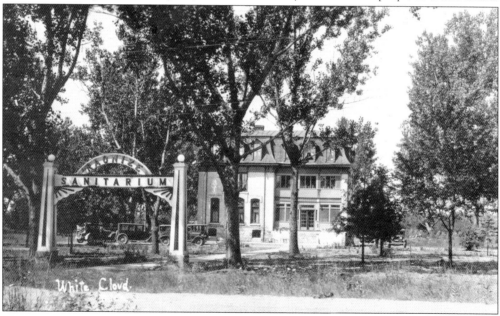

The first building in Morgan, the Morgan Inn, was erected in 1868. The structure was moved a short distance to North Street where Swain Street ends. The building was purchased by Dr. Calvin Ruttledge, who remodeled 40 rooms in 1928, adding electronic equipment and x-ray equipment. It was called the Raonize Sanitarium. It was not open long before closing in 1929, possibly due to the Depression.

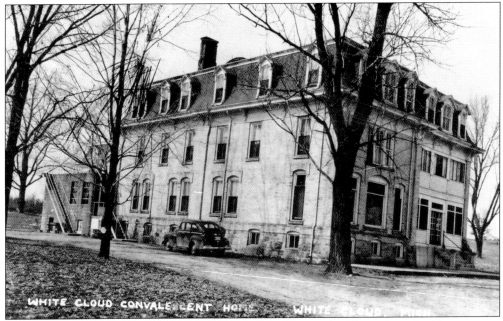

In 1942, John D. Garrison purchased the Raonize Sanitarium building after it had been vacant for over 12 years. The building was remodeled to accommodate 42 patients and was licensed by the state of Michigan. It opened as the Garrison Convalescent Hospital, providing 24-hour care. A fire destroyed this building in 1952. All patients were safely removed. This location is now Maple Lane Trailer Park.

This is the Roy Rivait Building. In the early 1900s, Riviat had a garage and implement shop here. He then had a Ford dealership in the 1940s. In the 1960s, the building became a laundromat under new ownership. The White Cloud High School marching band is shown in the 1970s. The building burned down in the late 1970s. (Rosie Alger.)

Originally built in 1893, the White Cloud Feed Mill was a key fixture in the Village of White Cloud. Built by Henry and George Rauch, it operated as a flour mill from 1893 through 1920. With the railroad already next to the mill, produce could be easily shipped to and from there, so it opened up a new way to sell the town's produce. In 1919, Jake Allers, Fred Anderson, Voight Godfrey, Bert Johnson, and Jim Terwillegar organized the White Cloud Co-Operative, purchasing the mill and property from a Mr. Selin. Seventy-five farmers banded together to get better prices for their grain and livestock. They opened a store and sold seed to farmers. The mill purchased the farmers' grain to be ground at the mill. Coal was the main source of heat in White Cloud, and there were always large piles of coal along the railroad tracks.

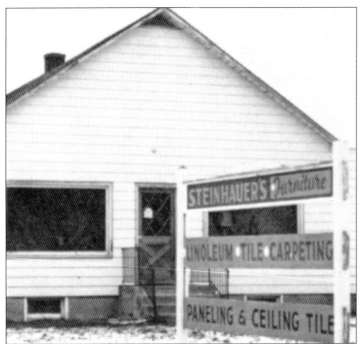

Steinhauer Furniture purchased this property at 1293 East Wilcox Street in 1938. There was an Army surplus store on the east side of the building. For many years, Waldo Steinhauer sold furniture, lamps, mattresses, floor coverings, and carpets. Steinhauer later turned part of the building into apartments. He sold the business to Marvin Deur around 1972.

Gordon Baumunk was a residential builder for many years in the White Cloud and Big Rapids areas. When Baumunk started his business, he and his wife, Ruby Fowler Baumunk, lived on East Wilcox Avenue in White Cloud. The business was at 177 Maple Street. Multiple homes in White Cloud were built by Baumunk. This is a current picture of what was his shop.

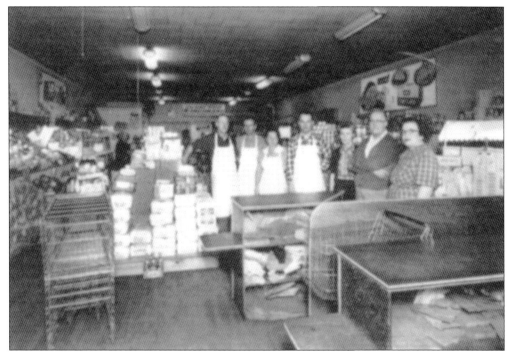

In 1910, William S. Bird established Bird's Food Market. William's sons Marion and Marshall Bird owned it next, becoming the second generation of Birds to own the business. This picture shows the inside of the store. From left to right are Marion Bird, Joe Foster, Hazel Bird (Marion's wife), Bill Fowler, Gladys Hopper, Marshall Bird, and Clara Mae Bird (Marshall's wife).

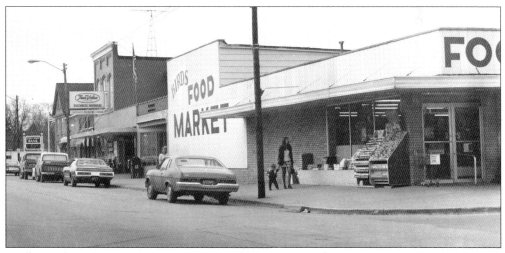

Bird's Food Market was on the corner of Wilcox Avenue and Benson Street. The business had four generations of family owners. The third generation owner was William "Bill" Bird, son of Marshall Bird. In the 1970s, Marshall's son-in-law Jerry Laninga joined the business. The fourth generation was Billy Bird, son of Bill Bird. The store was sold in the late 1990s to the Housemans from Kent City. (Rosie Alger.)

S.K. Riblet was the third generation of Riblets in Newaygo County. He was named after his grandfather Solomon Kuiper, who came to Newaygo in 1856. In 1925, S.K. received a law degree from the University of Michigan. In 1932, he purchased this abstract office on Wilcox Avenue from his father, Fred. S.K. lived in White Cloud and was very active in the White Cloud community.

Marion and Ruth Cruzan's home at 1305 Swain Street was built in the late 1950s by the Cruzan Brothers Builders. Don and Marion formed the Cruzan Brothers Builders after World War II, after serving in the US Army. The first home built by the brothers was Joe Fox's residence at 1333 East Wilcox Avenue. Marion's son Duane joined the business in 1976, and Don and Marion retired in the mid-1980s.

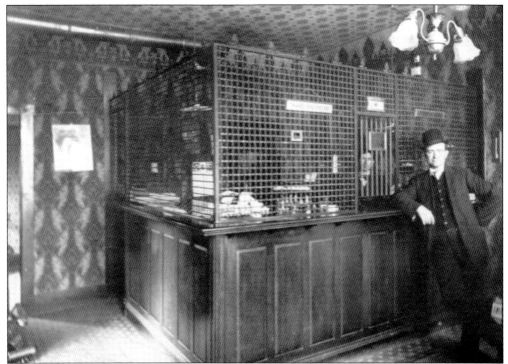

In 1903, Richard Gannon and his sons Ray and Charles opened the Farmers and Merchants Bank on Wilcox Avenue. In 1906, the Gannons purchased a privately owned bank from Corneluis G. Lenington, renaming it R. Gannon and Sons Bank. Pictured around 1910 are Ray Gannon (the cashier behind the screen) and customer Henry Tuttle, editor of the *White Cloud Star.*

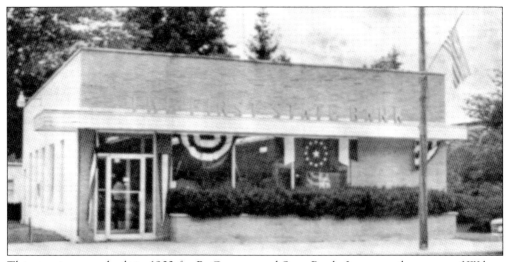

This structure was built in 1903 for R. Gannon and Sons Bank. It was on the corner of Wilcox Avenue and Benson Street, a spot later occupied by the First State Bank of White Cloud. On December 26, 1974, the First State Bank gifted the old bank building to the City of White Cloud.

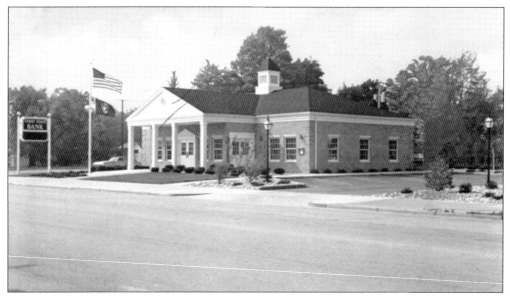

In the summer of 1974, the First State Bank of White Cloud moved into this new building at 1075 East Wilcox Avenue, on the corner of Gibbs Street. This bank failed in February 1988. It has changed ownership over the years. Currently, it is the Independent Bank of White Cloud. (Rosie Alger.)

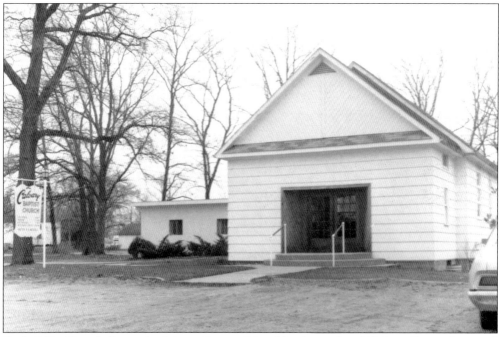

Faith Bible Church (formerly Calvary Baptist Church) is located at 113 State Street. It started as a prayer meeting in the home of Clara Caplin in 1952, moving to the Johnson building with 17 followers, then meeting at the Seventh Day Baptist Church from 1954 to 1957. The church was organized from a fellowship to a church in 1956 and moved into the little building in 1957. (Rosie Alger.)

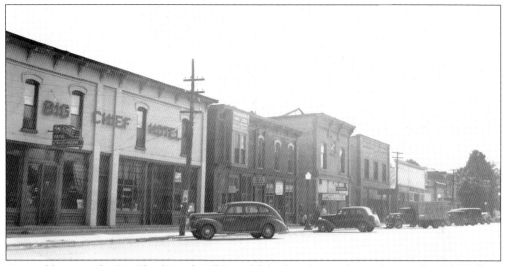

Pictured here are the Big Chief Hotel, Bill Brandt's barber shop and rental units, the Odd Fellows Hall, AQ Adams Hardware, Branch's Dry Goods, and LeMire's drugstore. Branch's Dry Goods and Adams Hardware are the only buildings that remain. These buildings are on the south side of Wilcox Avenue. (Rosie Alger.)

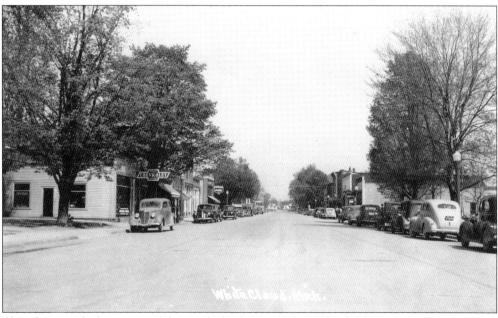

This photograph shows one of the car dealerships in White Cloud. The picture was taken near the corner of Wilcox Avenue and Gibbs Street looking east. The building with the Chevrolet sign is now part of the Independent Bank parking lot. The next building to the east is now part of the post office.

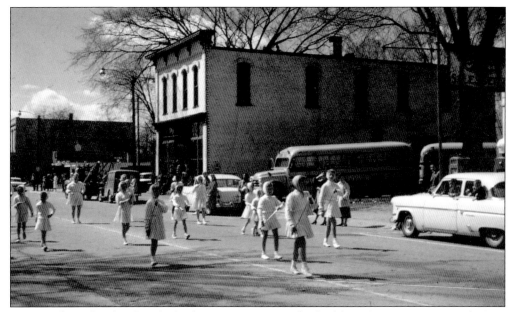

In 1900, the Cohen brothers had a department store in this building. At one time, it was the Lew Meadows Saloon. Other businesses here included Mudget's garage, Central Farm Supply, Prestley's feed store, Thompson's feed store, and Lucky's auction house. Attached to the back of the building was Burt Ellis's body shop, along with various other car repair businesses over the years. This is now the site of the Independent Bank.

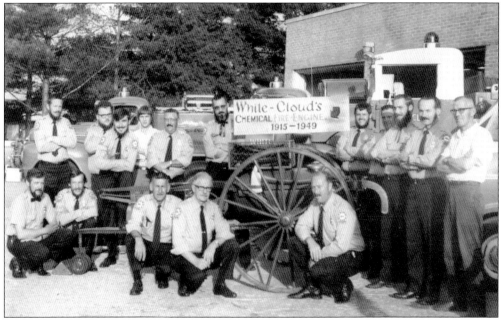

This is the 1973 White Cloud Fire Department. There were 19 active volunteer firefighters that year, and 16 of them are in this photograph. Pictured from left to right are (first row) Don Rudert, John Krizov, Ed Green, Elmer May, and Bill Richards; (second row) Larry Simpson, Charlie Kraus, Sam Cruzan, Eldon Harris, Al Fry, Clayton Fetterley, Chuck Hooker, Clifford Plowman, Gene Johnson, chief Bill Fowler, and Jim Gardenour. (Rosie Alger.)

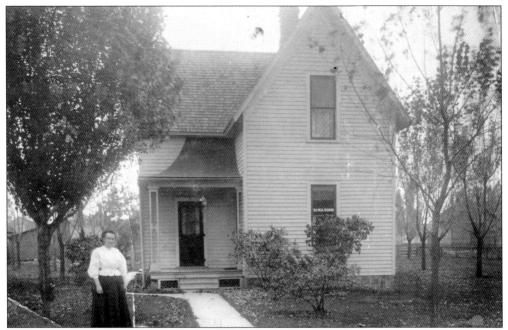

This home was on the south side of Wilcox Avenue just east of the Big Chief Hotel. It was owned by Dr. William Kuhns and later occupied by the Al Kymes family. This area is now part of the Rosenberg Hardware parking lot.

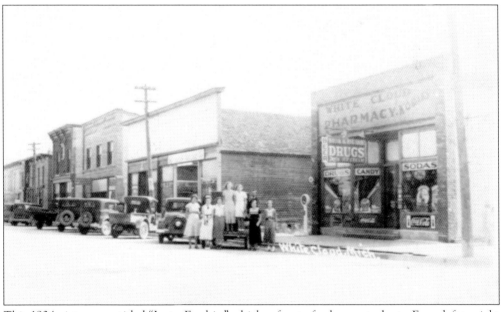

This 1934 picture was titled "Just a Freshie," which refers to freshman students. From left to right are Marie Cordts, Dolly Twing, Juanita Christenson, Aileen Gibbs, Rosie P., Anna M., and Ruby Fowler (George P. is behind the girls). The drugstore had a popular soda bar and take-out ice cream. Note the scales on the side of the building.

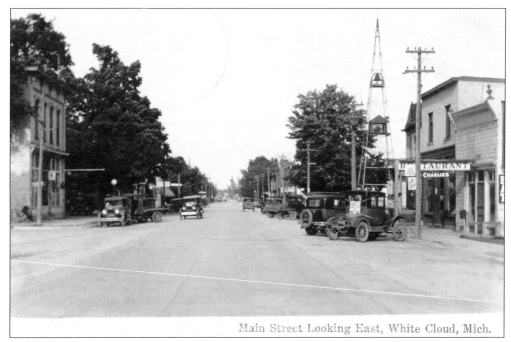

Main Street Looking East, White Cloud, Mich.

This photograph was taken looking east toward the corner of Wilcox Avenue and Gibbs Street. The large building on the left is now the location of the Independent Bank. Note the cluster of businesses on the right and the tower with the fire bell near the top.

The Johnson building sat on the corner of Wilcox Avenue and Charles Street for over 100 years. It housed many businesses, including grocery stores and restaurants. The Kom Bac Inn, pictured here in 1944, was operated by Ann Stanley and known for its excellent food. From left to right are Ann Stanley, Joe Foster, and Julia Ruttkowski. (Rosie Alger.)

This 1996 photograph shows firefighters Duane Cruzan (left) and Rick Sharp doing a demonstration during Fire Prevention Week. In the background is the dental office of Dr. John Schondelmayer. Schondelmayer started his practice in 1981, and it is now Life Care Dental. In 1980, Dr. Robert Gunnell moved his Grant medical practice to White Cloud, naming it White Cloud Medical Center. Both doctors have served the community for decades.

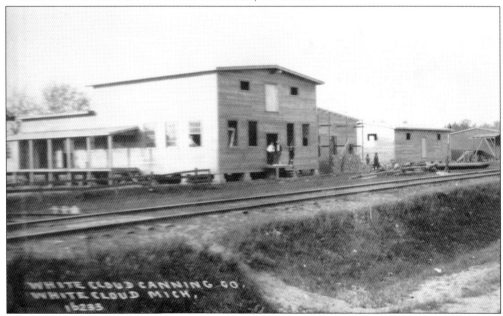

Pictured here is the White Cloud Canning Company on Adda Street. Beans were canned here from 1910 through 1930. The beans were purchased from local farmers. The canning factory employed 30 workers in the summer months. This picture is from the back of the factory, which faced the railroad tracks that ran east to west.

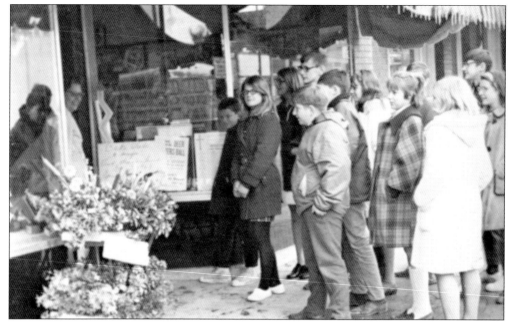

Evans Five and Dime Store (opened in 1962) was owned and operated by Martha Evans, who was civic-minded and active in the community. She was instrumental in organizing the Newaygo County Historical Society, served on the chamber of commerce, was director of the tourist council, served as secretary of the Newaygo County Economic Development Commission, and was a member of the executive boards of the West Michigan Tourist Association and West Michigan Planning Commission.

Dr. Sidney "Doc" Douglass, pictured here on the left with Kocky Eldred, began his medical practice in 1930. In 1952, he was named White Cloud Man of the Year for his many contributions to the community. In 1953, he built the brick doctor's office at the corner of Wilcox Avenue and North Street. Doc left the community many valuable records of the old days, which are now housed in the White Cloud Community Library.

Seven

GOVERNMENT BUILDINGS

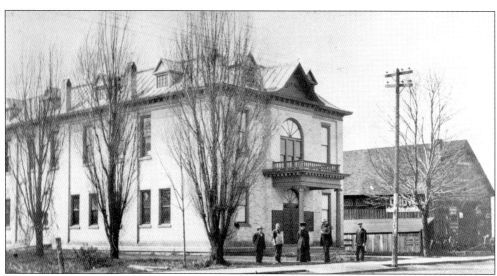

In 1903, White Cloud lost a bid to bring the county seat to town by only 214 votes. This acted as an incentive to build a much larger city hall. The building was dedicated on February 20, 1908. The move to bring the county seat to White Cloud was successful in 1910, and the city hall turned into the county building.

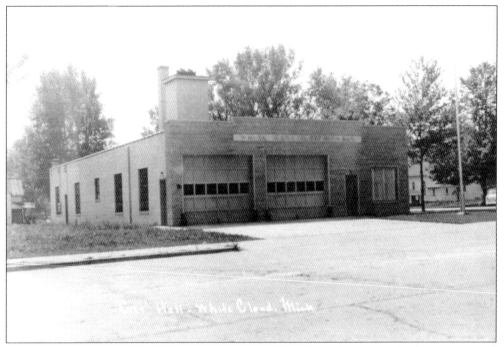

In January 1952, White Cloud built a new city hall and fire barn on the corner of Wilcox Avenue and North Street. There were two fire department bays, plus a drying tower for fire hoses. Every winter, the fire department would flood the side parking lot to create a skating rink for the community to enjoy. Later, two more bays were added. (Rosie Alger.)

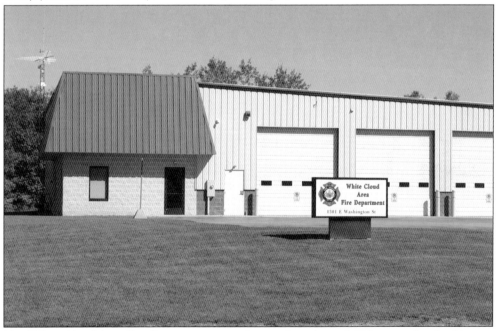

The White Cloud Area Fire Department moved into a brand-new 8,000-square-foot building in November 2014 in the White Cloud Industrial Park. The White Cloud Area Fire Department serves the city of White Cloud and the townships of Everett, Wilcox, Sherman, and Lincoln.

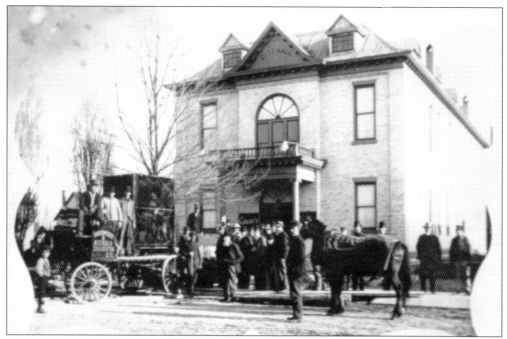

In 1910, Adelbert and Erastus Branch presented a heated argument that White Cloud was the logical spot to be the seat of Newaygo County. Newaygo's courthouse was ready to be scrapped. White Cloud had a beautiful new building and was located directly in the center of Newaygo County. Erastus persuaded enough reluctant supervisors to approve the move. Pictured is one of the four safes that were moved into the White Cloud courthouse.

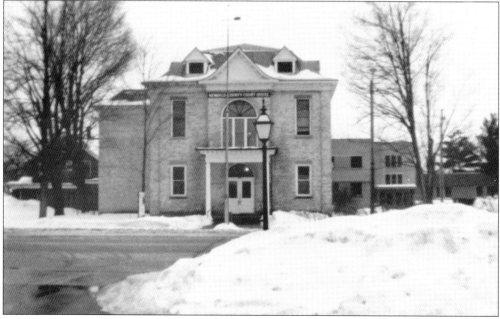

In 1910, after a heated battle with the Village of Newaygo, White Cloud won the vote to become the county seat. The loss was not a death blow, as there were more important things happening in Newaygo, such as new factories. Newaygo's desire to remain the county seat was mostly sentimental.

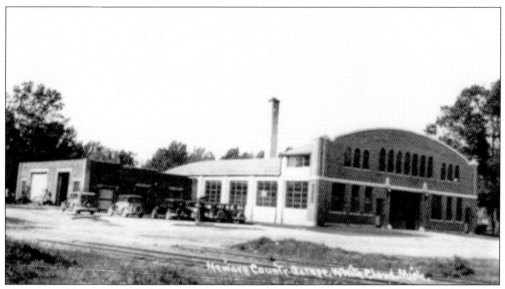

The original location of the Newaygo County Road Commission was at 93 South Gibbs Street. Foster Mudget sold the property to the road commission in 1923. The building is now the Newaygo County Commission on Aging, with the Newaygo County Road Commission having moved to One Mile Road (also known as M-20).

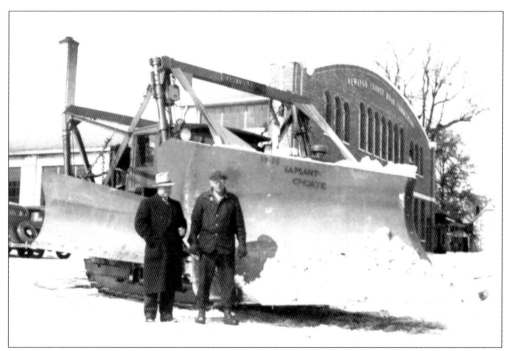

This LaPlant Choate road scraper was used in the early days to maintain the roads. The machine moved so slowly that each day, it was left wherever the driver stopped at the end of the shift. Each crew had to take fuel and whatever supplies were needed to maintain the tractor back to it.

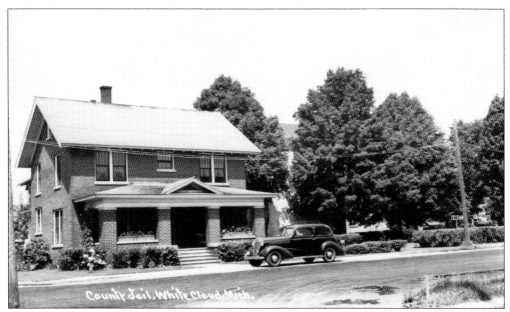

A bond passed in 1912 for this building to be a permanent jail and sheriff's residence on Williams Street. It served Newaygo County and the City of White Cloud. Sheriffs who resided here included David Moote, Noble McKinley, Riley Tindall, John Ramsey, William Bird, Robert Hart, and Robert Dougan.

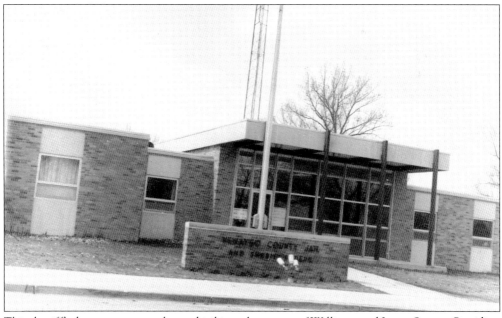

This sheriff's department complex and jail is at the corner of Williams and James Streets. Presiding sheriffs included Kenneth Muma, Leonard Somers, Ronald Vos, Roger Altena, Michael Mercer, Patrick Hedlund, and Robert Mendham. In 2010, a new sheriff's department was built when the federal prison expansion was added to the jail. (Rosie Alger.)

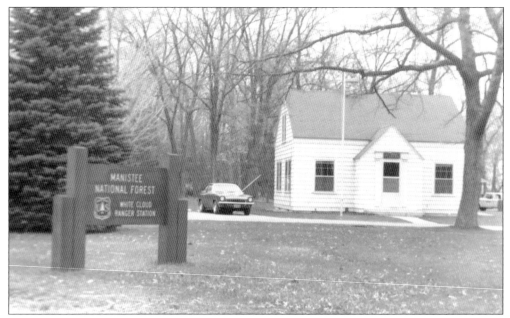

The Manistee National Forest White Cloud Ranger Station was located at 12 North Charles Street. The ranger station and garage were built by the Civilian Conservation Corps around 1936. The White Cloud Forest District served the area of Manistee National Forest that included Newaygo County and some of Oceana and Montcalm Counties for about 60 years before it was redistricted to Baldwin around 1994. (Rosie Alger.)

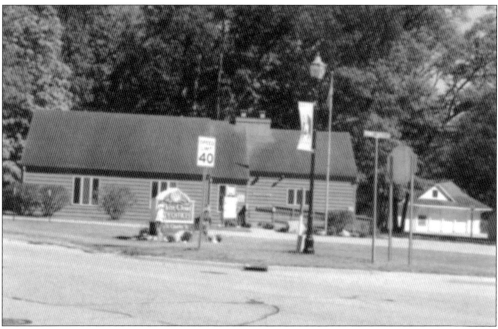

After the US Forest Service moved to Baldwin in 1994, the ranger station sat vacant. The City of White Cloud leased the building from the federal government and held an open house for the city offices and police department on December 31, 1997. The city later purchased the buildings. The White Cloud Department of Public Works is located near the airport.

Eight

Parks and Recreation

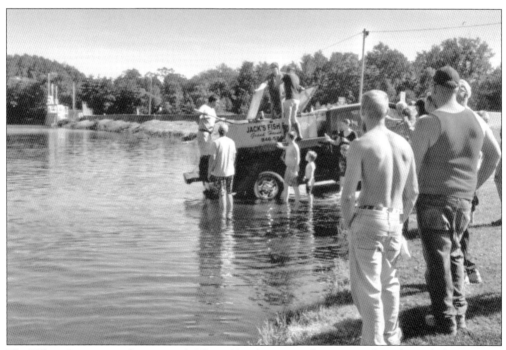

The White River meanders around White Cloud, gracing the town with parks and playgrounds. The river is a designated trout stream. The Russ Gilbert Kids' Free Fishing Day has taken place for 40 years. Starting in 1983 and every year since, on the first Saturday of June, White Cloud comes alive at Smith Park and Rotary Park, with hundreds of children excitedly anticipating a chance to catch the tagged fish. (Russ Gilbert family.)

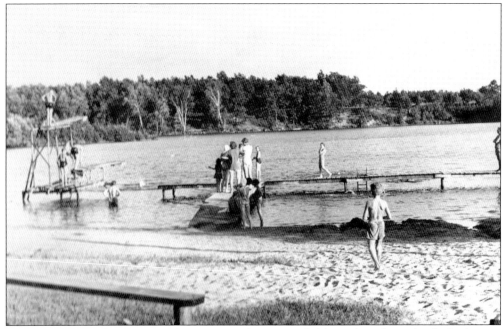

Swimming, diving, life-saving, and water safety classes were held at Lake White Cloud, also known as the Mill Pond, each summer, sponsored by the American Red Cross and the White Cloud Rotary. In 1952, Joan Johnson was the director, Helena Kaczynski was the instructor, and Joe Stanley was the lifeguard.

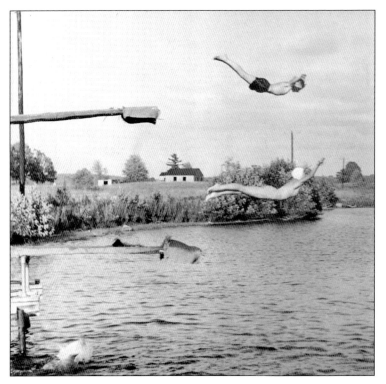

This 1952 photograph shows Jack Fox diving off the high board and Jean Russell diving off the lower board at Lake White Cloud. The summer program at the Mill Pond provided learning and fun for area children. It was a rite of passage to gather enough courage to finally jump or dive from the high board.

The Cruzan Little League Park is named after brothers Marion and Don Cruzan, who owned the land where the park is located. Around 1956, the Cruzans, along with the community, hand-dug and developed the first ballfield to the west. Over the years, the community came together to build the second field. These fields have been enjoyed by thousands of children. From the late 1800s to the early 1900s, this property was a quarter-mile horse racing track.

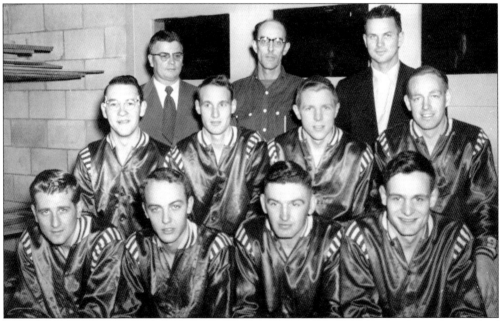

The White Cloud Oilers were an independent basketball team sponsored by Fowler-Burke Standard Service. The team formed in the late 1940s and lasted until the mid-1950s. Pictured here from left to right are (first row) Ken DeBlake, Bob Ellis, Lynn Gibson, and Jerry Mudget; (second row) Keith Eggerstedt, Wayne Fetterley, Bill Eckstrom, and Gil Edson; (third row) Andy Burke, Bert Ellis, and Barney Fowler. (Bob Burke.)

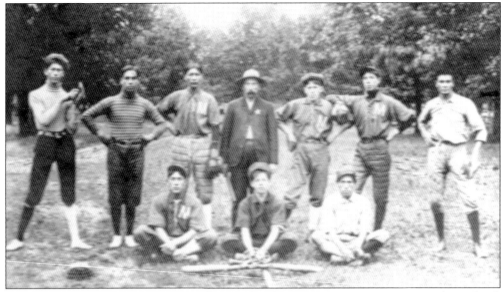

In 1906, the Cobmoosa Indians baseball team played numerous winning games in White Cloud. Pictured here are, from left to right, (first row, seated) Henry Negake, Frank Bunnell, and Chris Mitchell; (second row, standing) John Lewis, Joe Shagonabe, John Clingman, Charles Caswell (marshal of White Cloud), Lewis Genereaux, Andrew Bailey, and Burt Pego.

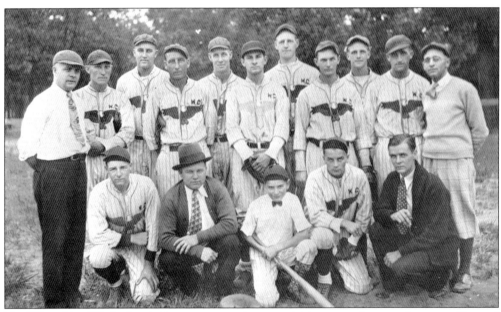

The White Cloud Eagles baseball team competed against visiting teams from nearby towns. Pictured in 1931 are, from left to right, (first row, kneeling) Ancil Sanford, Ted Branch (manager), Carl Gustafson (batboy), Andy Burke, and Carl Green (press); (second row, standing) Henry Gustin (umpire and manager), Max Regal (pitcher), Charles Johnson, Clyde Bowman, Tom Hepinstall, Alvon LeMire, Hugo Simpson, Frank Henderson (from Grant), Karl Eldred, Mac Slade, and Ben Adams (coach).

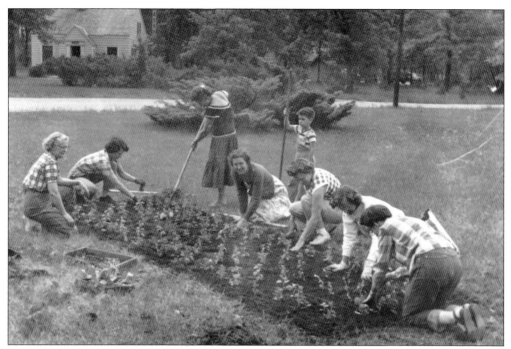

The White Cloud Garden Club is shown planting flowers at Ranger Station Park on the corner of M-37 and Pine Hill Street. The garden club made the park a welcoming place for locals and travelers to stop and picnic. The little park had a log picnic shelter and a fieldstone fireplace and ample room for community events. The Atlantic Hotel once occupied this property.

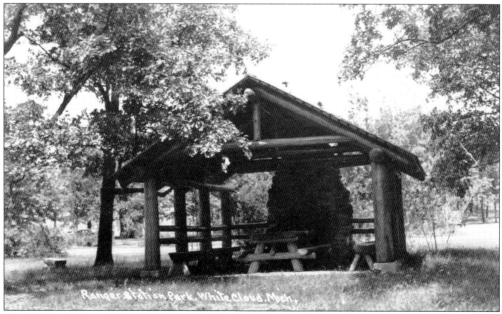

Ranger Station Park was across the street from the US Forest Service ranger station on the present site of Family Dollar at 18 Charles Street. The park's log picnic shelter was built at the same time as the ranger station, around 1936, by the Civilian Conservation Corps. The park also boasted a shuffleboard court.

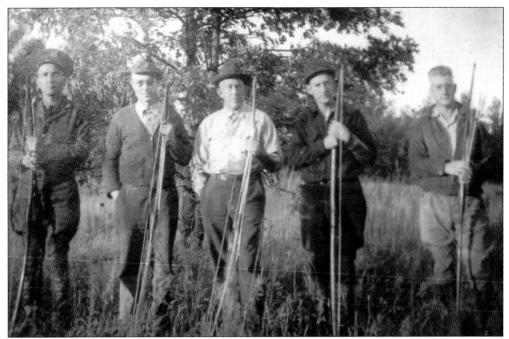

With hundreds of acres of the Manistee National Forest available, deer season is popular with both gun and bow-and-arrow hunters. Sportsmen have traveled to the area from near and far for years. Pictured here are, from left to right, bow hunters Alger Cline, Merle Talbert, Bill Martin, Carl Love, and Carlton Beckman. (Suzie Fetterley.)

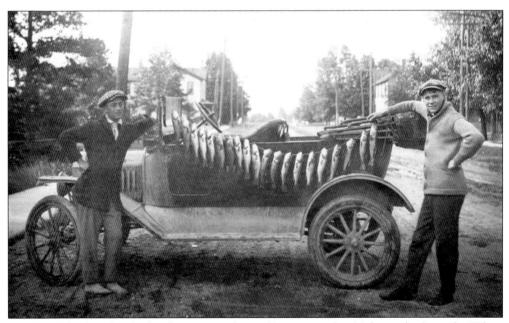

Roy Rivait (left) and Orlo "Pat" Patterson show off a nice catch of fish caught from the White River, a designated trout stream that has brought (and continues to bring) many fishermen into the area. The men are pictured with a 1915 Ford. Rivait sold Fords for a living, and Patterson was his buddy in many a scrape.

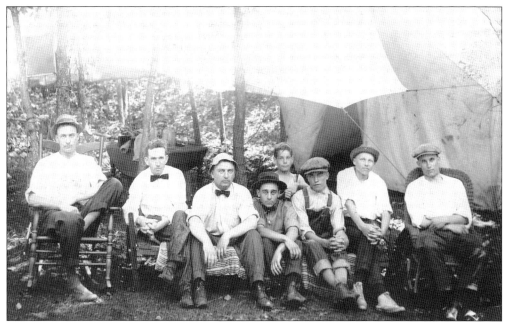

Attending a White Cloud State Park reunion are, from left to right, Dick Cooper, Getty Rosenberg, Wayne Rice, Ben Adams, Joseburg, Vic Gust, and Carl Brandt. The young boy's name is not known. The reunion was an annual weeklong event and was well attended.

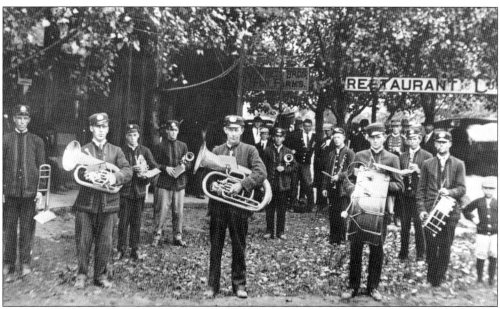

The 1906–1907 Erickson Band from White Cloud plays at the Old Reunion Ground, which later became White Cloud State Park. From left to right are Ed Johnson (trombone), Wes Pierce (alto horn), Len Erickson (French horn), Alfred Erickson (trumpet), Judy Hansen (bass horn), Charley Erickson (trumpet), George Gibbs (clarinet), Collin Decker (bass drum), Harold Erickson (clarinet), Jean Decker (snare drum), and Frankie Rivait (mascot).

This artesian well was created by a dynamite blast and has been flowing since 1906. In the early 1900s, Walter Reed took a great interest in the well. Chemists tested the water and told him that it was free of bacteria. Reed declared the water medicinal. In the early 1950s, the city gave the land to the State of Michigan, which returned it in 1983.

Walter Reed financed the construction of the fountains at Flowing Well Park. It was a beautiful picnic area for years. The White Cloud Garden Club planted and maintained the grounds. In 1977, Emma Graves started a fund to restore the area. Today, many people enjoy the beauty of the park.

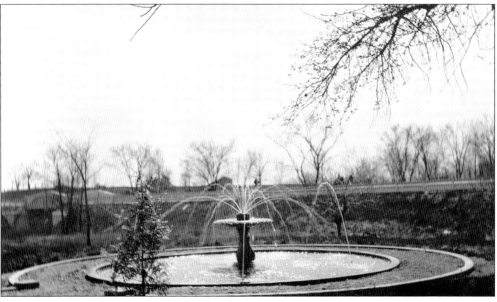

The frog fountain at Flowing Well Park was once a large glass fish tank that contained live fish. Standing in front of the unique structure is Pearle LeMire. The fish tank was vandalized and later became the frog fountain. Children enjoyed playing with the frog fountain and squirting the water. The frogs were later stolen. The fountain was filled with dirt, and flowers were planted. (LeMire family.)

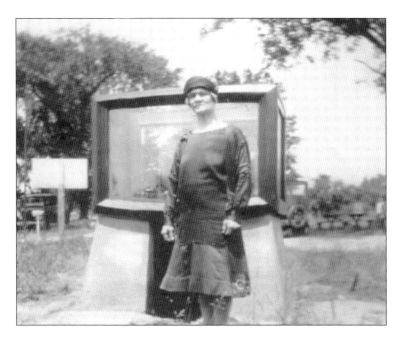

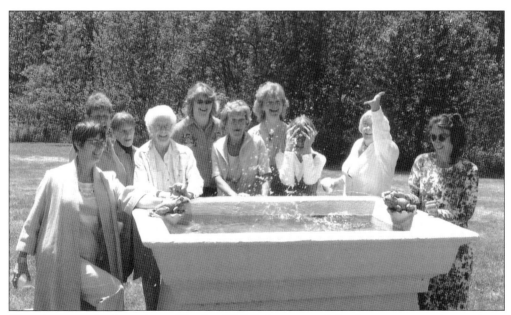

Over the years, the fountains at Flowing Well Park were vandalized—some were stolen, and two no longer worked. The White Cloud Garden Club held fundraisers for many years to restore the fountains and eventually did so with the help of volunteers and the community. This happy photograph shows the White Cloud Garden Club on May 31, 2009, celebrating the restoration of the frog fountain and the beauty brought back to Flowing Well Park.

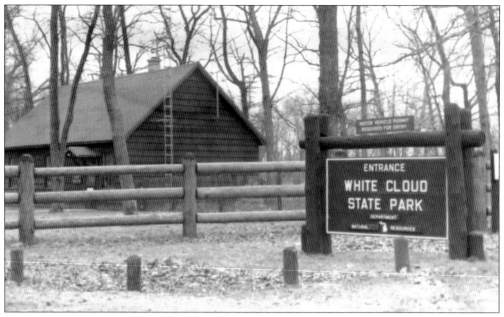

The 89-acre White Cloud State Park is at the west end of the city across from White Cloud High School. It is enclosed within a large historical log fence. Many gatherings have occurred here over the years. It is now managed by the Newaygo County Park System. (Rosie Alger.)

A large pavilion with a fireplace at the city park provides shelter for public gatherings. The park had tennis courts and playground equipment for those who camped. The campground now has accommodations ranging from primitive camping sites to full hookup lots, with a bathroom facility. The North Country Trail connector trail runs through the back of the park along the White River. (Rosie Alger.)

The North Country Trail stretches from Vermont to North Dakota, with White Cloud serving as the midpoint of the trail. The nearby Birch Grove Schoolhouse north of White Cloud served as the headquarters for the North Country Trail until it was recently sold. The trail can be accessed by a connector trail at White Cloud County Park and Campground.

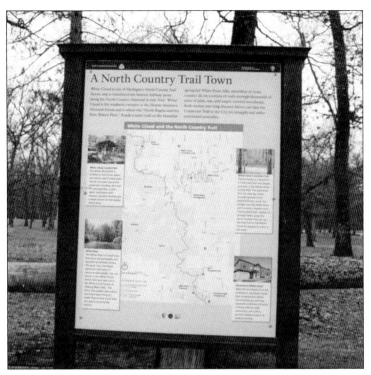

Brother and sister Mike and Mary Roach are walking to the back of their house at 1133 East James Street. Mike started working on the railroad as a section hand at age 14, moved to braking at age 21, and later worked as a freight train conductor until he retired. The best trail of all always leads us home.

DISCOVER THOUSANDS OF LOCAL HISTORY BOOKS
FEATURING MILLIONS OF VINTAGE IMAGES

Arcadia Publishing, the leading local history publisher in the United States, is committed to making history accessible and meaningful through publishing books that celebrate and preserve the heritage of America's people and places.

Find more books like this at
www.arcadiapublishing.com

Search for your hometown history, your old stomping grounds, and even your favorite sports team.

Consistent with our mission to preserve history on a local level, this book was printed in South Carolina on American-made paper and manufactured entirely in the United States. Products carrying the accredited Forest Stewardship Council (FSC) label are printed on 100 percent FSC-certified paper.

MADE IN THE